STUDIES IN NATURE

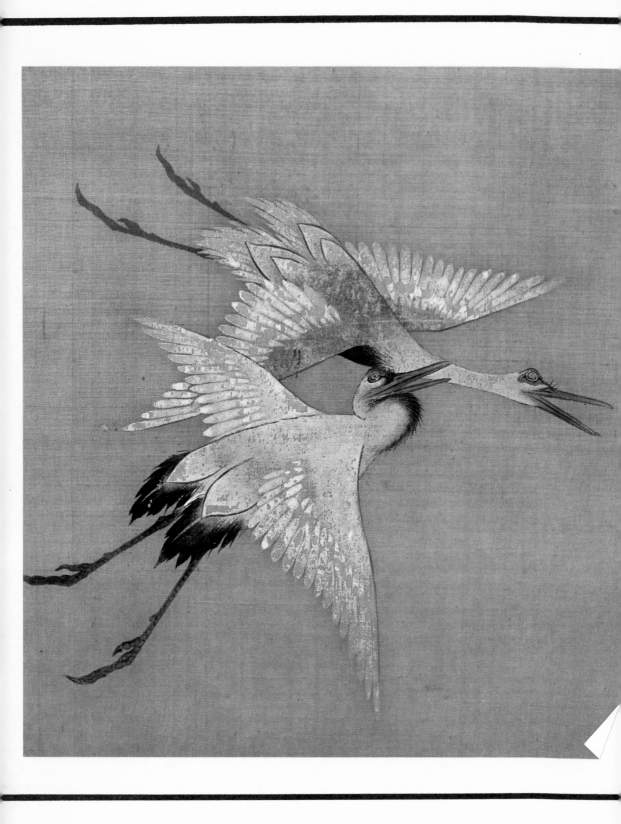

MASTERWORKS OF UKIYO-E

STUDIES IN NATURE
HOKUSAI · HIROSHIGE

花鳥風月

by Muneshige Narazaki

translated by John Bester

KODANSHA INTERNATIONAL LTD.
Tokyo, Japan & Palo Alto, Calif., U.S.A

Distributed in the British Commonwealth (except Canada and the Far East) by George Allen & Unwin Ltd., London; in Continental Europe by Boxerbooks, Inc., Zurich; in Canada by Fitzhenry & Whiteside Limited, Ontario; and in the Far East by Japan Publications Trading Co., P.O. Box 5030 Tokyo International, Tokyo. Published by Kodansha International Ltd., 2-12-21, Otowa, Bunkyo-ku, Tokyo 112, Japan and Kodansha International/USA, Ltd., 599 College Avenue, Palo Alto, California 94306. Copyright © 1970, by Kodansha International Ltd. All rights reserved. Printed in Japan.

LCC 76-82657
ISBN 0-87011-103-5
JBC 0371-781020-2361

First edition, 1970
Second printing, 1972

Contents

The Evolution of Kachō-ga

ONE OF the favorite themes of Oriental, and in particular Japanese, painting is what is known as "flowers-and-birds." The position of the "flowers-and-birds" picture (*kachō-ga*) is in some ways similar to the still life in Western painting, but its subjects are more embracing. A traditional method of classifying painting in China and Japan distinguishes three groups of subject: "Taoist and Buddhist figures" (in Japanese *dōshaku-ga*, the figures including both the divine, the legendary and the historical); "flowers and grasses, birds and beasts" (the same as flowers-and-birds); and landscape painting (in Japanese *sansui-ga*). This classification, however, has always applied chiefly to Chinese painting and the "Chinese" style in Japanese painting. The "Japanese" style that first developed in the Heian period has always included other, very literary types of picture that are difficult to fit into any of these three groups, and a similar, what one might call "literary," approach is often apparent in the purely Japanese *kachō-ga*.

What, precisely, is meant by the term *kachō-ga* (or *kachō fūgetsu*, another variant) as used in Japan? To consider this question is essential if one is to understand the true nature of the pictures by Hokusai and Hiroshige included in this volume. In the same way, some knowledge of the historical development of the form is also necessary to an understanding of the work of those two artists.

The aim of painting *kachō-ga* has, in the first place, never been simply to depict birds, flowers, and the like, but by depicting them to express some feeling about life, or to use natural scenes to express some subjective emotion. The term *kachō fūgetsu* is used in various slightly differing senses. First of all, it means, quite literally, "flowers-and-birds," (or either one depicted separately) and "wind and moon" (especially a breeze on a fine day and the full moon)—in other words, natural phenomena, and especially certain aspects of natural phenomena conventionally considered to be suitable subjects for art. Secondly, the term refers to the gently refined mind that finds pleasure in the contemplation of flowers, listening to the song of the birds, gazing at the moon, and generally giving itself over to the contemplation of nature. As an extension of these senses, the term *kachō fūgetsu* comes to

mean beautiful natural scenery, and as a still further extension, the refined, poetic way of life that finds its chief pleasure in the contemplation of such beauty. The Japanese as a race have never, throughout their long history, felt at home with the attitudes of natural science: they have tended to see nature not as objective reality, but as a subjective reflection of their own minds.

Generally speaking, the "thing in itself" can be viewed either in terms of natural science (botany, zoology, etc.), or of philosophy, or as a means of survival, or as a means to aesthetic experience. The Japanese have always tended to see it chiefly in terms of the last two. This is not, of course, to say that the theoretical or objective attitude was completely lacking. The view of nature held in China in ancient times was, in a sense, philosophical, and the influence was doubtless felt in Japan too. Chinese art, moreover, emphasized the need in portraying, say, a horse, to convey the spirit of the horse, and this doubtless represented a kind of objectivism. Indeed, the artist during his apprentice period would apply himself assiduously to sketching flowers, birds, and other natural phenomena from life. It is also true that as modern Western painting gradually became known in Japan, pictures done in an objective, botanical or zoological spirit were not uncommon. Yet despite such exceptions, the general belief throughout the ages has always been that, at the most perfect level of art, the greatest value was to be found in an extremely emotive approach. More often than not, a "thing" was seen, not as something existing in itself, but in its relationship to the artist's self, or to other things, or for its bearing on human life or society.

A concrete example of what is meant here can be found in the conventional couplings of "things and things," as themes for pictures. These may be dictated by a desire to suggest a particular season, or by their appropriateness to each other in terms of form or associative content. In painting, thus, it is extremely common to depict a particular plant and a particular animal or bird together. Thus a pine tree is most frequently combined with a crane, a carp, a hawk, an eagle, or wisteria blossoms. In the same way, we have bamboo and sparrows or a tiger; bamboo, grass and snow; plum blossoms and the Japanese nightingale or the moon; willow trees with swallows or frogs; peach blossoms with doves or swallows; oak trees with hawks; paulownia trees with phoenixes; peonies with butterflies, sleeping cats or *karajishi* ("Chinese lion," a fanciful beast rather distantly related to the real lion); *yamabuki* (a yellow member of the rose family) with frogs; rushes with ducks or wild geese; clouds with dragons; the moon with the Japanese cuckoo, clouds, hares, bats, or homing geese; waterfalls with carp; harvested ricefields with alighting geese; leafless trees with hungry crows; lonely creeks with solitary fishermen; and so on. Conventional combinations such as these—and there are many others—occur in both painting and poetry, the point being not merely a question of contrast and physical shape, but also the way the two objects combine to suggest a particular season, or create a pleasing harmony of associations.

8

In the early Japanese classics—anthologies such as the *Manyōshū* or *Kokinshū*, romances such as the *Tale of Genji*—a large proportion of the literary invention revolves around natural phenomena such as these. In every case, however, it is clear that the poet or author is not interested in their objective beauty, or in painting accurate pictures, but in using them as vehicles for his own emotions or ideas, or for a particular view of life. Thus the moon is never extolled for its intrinsic beauty but is used to prompt the poet into melancholy musing, or to suggest to him a mirror in which he would see his beloved's face reflected. The same thing is true of Japanese literature as a whole. The moon, the birds, the flowers, are never viewed as beautiful objects in their own right, but are invested with the writer's own yearnings, whether they be for a loved one or for some ideal state of being. Nature changes, yet is eternal. Human life, too, changes; but man, who alone is given the power to think, is fated to fade and fall like the cherry blossom. He longs accordingly to identify himself with—to become one with—nature. He reverses nature, and rates the natural grace of nature above the artificial style and elegance of man. Such, at least, was the traditional outlook of the Japanese. Nature was their ultimate home, life but a temporary lodging.

NATURE IN EVERYDAY LIFE

The regular round of the seasons in Japan brings all kinds of subtle changes in the appearance of the natural world. Some things are born and die within the year, others respond to the seasons by producing all kinds of phenomena that in themselves are but one part of a much longer life. In such things the Japanese have traditionally seen a miniature of human life, and have made nature an integral part of their own lives.

Among the things of which they are particularly fond are the ritual flower viewings that mark the changing seasons throughout the year. There is the plum blossom viewing that heralds the approach of spring, followed by the cherry blossom in early April; the lotuses in the summer, moon viewing, maple viewing, and chrysanthemum viewing in the autumn; and snow viewing in the winter. Besides these, various other natural phenomena, such as waterfalls or the changing tide, can be made an occasion for special viewing excursions. Sometimes the viewing is done alone, sometimes in parties; sometimes, even, it is made an excuse for a saké party. Special excursions to gather the fruits of nature, to fish, or to hunt also make ideal themes for painting; they include hunting, fruit picking, firefly catching, gathering shellfish at low tide, cormorant fishing, listening to the song of insects, mushroom gathering, and hawking.

The interest shown by the Japanese in nature, and in flowers in particular, is witnessed by the large number of words connected with flowers in the language. There is even a four-character phrase meaning "to hang one's loincloth to dry beneath the blossoms," used of an insensitive, boorish person. The poet who is

moved by the sight of flowers to declare that the world would have no meaning without them is a common figure. From ancient times, two of the favorite spots for elegant excusions by inhabitants of the capital of Kyoto were the banks of the Tatsuta River and the hills of Yoshino, celebrated for their autumn maples and their cherry blossoms respectively.

One of the favorite pastimes of the aristocracy during the Heian period was what was known as *awasemono* or "matching things." Typical of these were *uta-awase* ("poem matching") and *e-awase* ("picture matching"). Two people or more would sit together with a judge between them and set to composing poems, or painting pictures, on a given theme, then would dispute the rival merits of their work. It constituted a kind of literary or artistic criticism. Other similar amusements included *kai-awase* ("shell matching"), *mushi-awase* ("insect matching"), and *hana-awase* ("flower matching"). *Hanafuda-awase* ("flower-card matching") was a game pure and simple, a kind of gambling. There were even *uguisu-awase* (nightingale matching), *kumo-awase* ("spider matching"), and *niwatori-awase* (*tori-awase*). The last-named, which was nothing other than cockfighting, was a cruel sport, but it was offset by such gentle pastimes as *hana-ikusa*, the "war of the flowers."

There have been few peoples in whose everyday life nature has played such a great part as it has in that of the Japanese. This is borne out still further by annual rites and ceremonies such as the festivals of the Seven Herbs of Spring and the Seven Flowers of Autumn; the Flower Festival on the Buddha's birthday on April 8; the Rice-Planting Festival, at which young maidens wear azaleas in their hair as they perform the *dengaku* dance; the garden produce arranged as an offering at the time of the harvest moon, and so on. In all of these is apparent a feeling of thankfulness for the many blessings of nature that give a graciousness to life.

FLOWERS AND FORM

In Japanese, cherry blossom petals that have fallen into the water and are carried along in clusters are referred to, with typical Japanese fancifulness, as "flower rafts." The Japanese sensibility readily associated nature with aesthetic forms and also possessed a highly developed appreciation of form depending on contrast and harmony between different objects. A good example is the *kadomatsu*: a decoration of pine and bamboo set up outside the gateways of houses at New Year's in Japan and originally intended as a medium through which good luck might descend from heaven to take up residence in the household. It is common, again, to offer up branches of *sakaki* to the Shinto gods. It is also common to give flowers or fern as gifts, presented in a flower basket. Japanese food, which is unique in the emphasis it places on artistic appearance, is sometimes garnished with a flower solely for its decorative effect, and the manner of doing this also is determined by tradition.

An example of a high level of aesthetic sensibility set to work to beautify the

home is the art of flower arrangement. The aim here is not simply to make a display of beautiful flowers of the season, but to create a beauty of form by setting flowers, branches, and leaves against each other while at the same time harmonizing the total arrangement with its setting, i.e., the *tokonoma* alcove. The result is a type of formal beauty very different from that of the West.

In *ikebana*, wild flowers are often gathered for the purpose. In *bonsai* (cultivation of miniature trees), in marked contrast to flower arrangement, ten years—sometimes as much as fifty—may be devoted to producing a beautiful form. A pine tree, for example, is planted in a pot to keep it small while creating a shape suggestive of a great forest. This is another art peculiar to the Japanese; perhaps it was only made possible by a family system under which successive generations, living under the same roof, could devote the same care to a plant over many decades.

Japanese gardens are characterized by the attempt to imitate nature, to create a miniature of it within the small space of a garden. Here too, centuries of life are required for a garden to acquire its definitive form—which is very different from the garden of the West, with its geometrical patterns.

Thus flowers and natural form are intimately connected with the daily lives of the Japanese. They exist both outside and inside the home, a constant companion and a constant solace. As a result, they make their appearance in almost all Japanese art; one might almost suspect that without them Japan would have no art at all. Through art, man seeks to build a bridge to span nature and his own soul. In Japan, there are even *hanagoyomi*—"flower calendars," which list in chronological order the best places for viewing the flowers peculiar to each successive season. There is a word *umegoyomi*—"plum blossom calendar"—which refers to the custom of telling the advent of spring by the appearance of the plum blossoms in remote country areas where there were no other calendars. The crests of many families incorporate flower designs; and the Japanese have copied and extended the Western use of flowers to symbolize nations, cities, and towns; today, even banks and department stores use flowers as their trademarks.

The Anthropomorphization of Flowers

Flowers, which have no voice, and birds and animals, which have voices yet cannot communicate, are easily invested with human feelings. To put it in another way, they are often spiritualized and anthropomorphized. Thus in the West the rose becomes the symbol of purity; the laurel, of glory, and so on. Both China and Japan have long followed the custom of grouping flowers together to symbolize various human feelings or social bonds. Thus there are the "two friends" (plum blossom and chrysanthemum), the "three friends" (plum blossom, pine, and bamboo), the "twin purities" (plum blossom and narcissus), the "four loves," the "four purities," the "seven fragrances," and so on. The twelve signs of the zodiac of China are all animals; they were enthusiastically adopted by the Japanese, and make

their appearance in all kinds of designs in everyday life. In the same way, there are countless everyday Japanese expressions in which the word "flower" is incorporated in the sense of "especially desirable," "outstanding," "brilliant," "gay," and so on, or in which particular flowers are likened to human beauty or human virtues. The same kind of thing occurs in other cultures and languages of course, but in Japan it occurs with a frequency almost unimaginable elsewhere.

ANIMALS AS SYMBOLS

In religions such as Buddhism and Shinto, it is very common for divine beings to be represented accompanied by animals, or to symbolize them by animals. The bodhisattva Kannon is commonly shown accompanied by a crane. One manifestation of the same Kannon stands on a dragon's head. The bodhisattva Fugen is shown riding on an elephant, while the bodhisattva Monju rides a lion. In the same way, the "hermits" of Taoism are shown riding on carp, deer and the like. The gods of Japan's native Shinto are represented by animals—Kasuga by a deer, for example, Inari by a fox, and Hiyoshi by a monkey. Such symbolic representations of things of the spirit occur frequently in painting and sculpture, and there are even symbols of natural forces, or of strength in the abstract, such as the Gods of Wind and Thunder or the "Battle of Dragon and Tiger."

PICTURES OF ANIMALS AND FLOWERS AND THEIR HISTORY

Animals, plants and other natural phenomena are used extremely widely in Japanese art, but generally speaking one can consider them under two main headings: design, and pure art. These two aspects have existed side by side throughout Japanese history, and it is difficult to say that either of them preceded the other. The early pictures in which the primitive Japanese sought to portray something of their own lives include, in hunting scenes, pictures of dogs and deer as well as such familiar creatures as turtles, fish, dragonflies, and frogs. They include some that convey a suggestion of juvenile art in the innocence with which they fail to distinguish between the self and the outside world.

This would suggest that the very first use made of plants and animals in pictures was in close relation to everyday life—more specifically, on articles such as the clothing necessary to keep the body warm, on personal accessories, and the like. It is customary to decorate Japanese clothing with representations of flowers and plants, birds and animals; the best examples are to be found in women's clothing of the Edo period. Such pictures are also incorporated into designs used on articles of everyday use; undecorated lacquerware and porcelain are comparatively rare, most being embellished with pictures depicting natural objects. As men became increasingly aware of their dwellings as places in which to relax, they began to paint pictures of plants and animals on walls and doors. The examples of decorative art found in the Shōsōin Imperial Repository—which admittedly probably

represent the very best of their period, since they were used by the Emperor Shōmu —include a great deal of work of astonishing refinement. Shinto shrines disliked ornament of any kind, but the Buddhist temples produced, in the lavish depiction of Buddhist paradises and the like, much that represented the ultimate. They included very many representations of plants, birds and beasts, to which, it was believed, the teaching of the Buddha applied in the same way as to human beings. Decorative designs, too, included very many derived from grasses, vines, lotuses, and imaginary flowers such as the *hōsōge*.

We have very few examples of the painting of the Nara and Heian periods. It seems likely that under the influence of Chinese art, pictures of animals and flowers were painted for the purpose of aesthetic appreciation, but nothing has survived for us today. Flowers and birds occur in various forms in designs, however, and are frequently mentioned in the literature of the Heian period. Thus it seems almost certain they were used as the subjects of paintings as well. Written records suggest that the *kachō-ga* was already flourishing in the *Yamato-e*, and the celebrated *Tale of Genji* picture scroll, attributed to Fujiwara Takayoshi, affords actual proof that such pictures were being painted on screens, sliding doors, and elsewhere. Another good source of information is the fan-faces inscribed with sutra texts that are preserved in the Shitennō-ji temple. These paper fan-faces have, beneath the brush-written texts, pictures printed from wooden blocks and depicting, among other subjects, the "seven grasses of autumn," a hawk on a tree with a hare in the grass beneath, and other subjects reminiscent of the work of the Edo period. The fact that wooden blocks were used to print these pictures is an indication that the same type of picture was used for ordinary fans sold on the market also. The *Yamato-e* included pictures showing yearly rites and observances, famous sights, and scenic spots, and it seems likely—particularly since the Japanese people have a natural love for birds and flowers—that a large number of pictures on these subjects were produced also. The fact that the *Yamato-e* was frequently used as a means of interior decoration makes this seem still more likely. In the same way as the poetry of the period, Heian period art dealt with the things that were to be found in man's natural surroundings; and the use of such themes on clothing and articles of personal adornment, as well as for interior decoration, is typical of the aristocratic, urbane nature of the culture of the period.

In the art world of the Ashikaga period, the *Yamato-e* went into a decline, and a "Chinese" style of painting known as *kanga* and derived from the styles of Sung and Yüan came to dominate the world of painting. Although the ink monochromes of Sung and Yüan are mostly landscapes, they also include some flower-and-bird pictures. The teachings of the Zen sect of Buddhism, moreover, emphasized the need to shun human vanity and, as it were, "get back to nature." This led to a taste for pictures on natural subjects, whether landscapes or flower-and-bird subjects. The Zen monks who produced so much painting during this period

did it as a leisure activity, and frequently confined themselves exclusively to one subject. For this purpose, flower-and-bird subjects were ideal; thus Bompō is noted for his pictures of orchids, Nikkan for his grapes, and so on. There are a considerable number of ink monochromes, moreover, in which flowers such as plum blossoms, bamboo, orchids, and chrysanthemums are represented, not for their own sake, but for the spiritual message conveyed by their forms.

At the same time, the "Academy style" of realistic portrayal from nature was also introduced into Japan. It is safe to say, probably, that the foundations of the *kachō-ga* as it was known later, during the Edo period, were laid during this period. During the same period, too, the *tokonoma* alcove became a regular feature of the dwelling houses of the well-to-do, a fact that enhanced the effectiveness of the landscape and *kachō-ga* considered as art pure and simple. The number of *kachō-ga* from this period that are still extant today is far from inconsiderable.

With the Azuchi-Momoyama period, the prevailing view of painting underwent an important change. To put this change at its simplest, it represented a new emphasis on actuality. Men seemed to lose their faith in the spiritual, the theoretical, and the absolute, and to turn their attention exclusively to living reality. During the previous Ashikaga period, continuing civil strife had destroyed the notion of authority. A new system of values thus had to be evolved. Religion could no longer be relied on to provide salvation. The only undeniable reality was the reality of men's everyday lives and the actual world that they saw about them. Eternity was something not to be believed in; but life's moment-to-moment experiences could be known directly. From such uncertainties, an art of actuality was born. In painting, the result was the production of *kachō-ga* and pictures of human figures and scenes that relied solely on the evidence of the senses—to the point, even, of excluding emotion altogether. It was from these human figures and scenes—the genre pictures—that the ukiyo-e was to derive, including the art of both Hokusai and Hiroshige.

The Daikaku-ji, the Myōshin-ji and other temples of Kyoto, as well as Nijō Castle, harbor many sliding door paintings illustrating the *kachō-ga* of the early Edo period; there are many screens in the same vein also, all of them bearing witness to the pleasure taken during that period in purely visual observation. There is also a considerable number of pictures showing celebrated scenic spots—pictures of cherry blossom viewing, for instance, or of maple viewing in the autumn. This taste for the decorative was to be elevated by the painter Sōtatsu into pictorial art of a high artistic level. The artistic lineage that Sōtatsu began was to develop the flower-and-bird picture greatly; and a succession of first-rate artists, from Kōrin and Kenzan on to Hōitsu, were to use the medium to give expression to the sensibility of the aristocracy and wealthy merchant class.

Sometime after the beginning of the eighteenth century, a change came over the painting of the Edo period as a result of the fresh influences from China and

Holland that came into Japan via Nagasaki. A major product of this influence was the Nanga school of painters. The work of the masters of this school is characterized by an emphasis, even in their landscapes and *kachō-ga,* on the pre-eminence of the spirit. It is a subjective, emotive style. The second product of the new influences was a new interest in realism derived from the painting-from-life of Ming and Ching China and from the realism of Europe. The aforementioned artists of the Nanga school also produced a certain number of *kachō-ga* based on sketches from life, but it was the Shijō school begun by Sō Shiseki of Edo and Maruyama Ōkyo of Kyoto that first set itself up as a school explicitly committed to realism.

From around 1750 on, the so-called Dutch studies became popular, and the need to produce illustrated manuals of birds, beasts, and plants to satisfy the new interest in the natural sciences greatly enouraged the realistic depiction of flower-and-bird subjects. New species of birds, even, were introduced from abroad, which prompted various artists to portray them. In the East, pictures of animals and plants have been referred to since ancient times in terms that suggested that the aim of the picture was not merely faithful representation, but to convey the inner spirit of the subject, and much thought was doubtless devoted to the question of how to depict the subject so that its true essence was apparent. One solution found was to make the utmost use of the purely reproductive powers of the picture, setting down in line and color exactly what the artist saw. This was the course adopted by the realistic artists of the Edo period, who rejected emotion and subjectivity and sought instead to portray reality from an objective standpoint. Whereas the *kachō-ga* of the Heian period was chiefly intended to evoke poetic emotions, that of the Edo period was created primarily for its purely visual, sensuous appeal.

The Flower-and-Bird Picture in the Ukiyo-e
The term "ukiyo-e" comprises both paintings and woodblock prints. The ukiyo-e was a development from the realistic painting of the early Edo period, and as such naturally inherited both the genre and the flower-and-bird subjects of the art of that period. In practice, however, by the middle of the Edo period (around the Genroku Era, 1688–1704) almost no *kachō-ga* paintings were being produced, and pictures of beautiful women (*bijin-ga*) held almost exclusive sway. In Kyoto, the *kachō-ga* of the Sōtatsu school were popular; the ukiyo-e made little headway, and it seems likely that the few that were produced were mostly *bijin-ga*. Increasingly, the new city of Edo was becoming the focal point of the ukiyo-e. Most likely, it was the tastes of the merchants and wealthy men of Edo of the period around the Genroku era—who were preoccupied almost solely with the pursuit of pleasure—that accounted for the emphasis on human figures in the unending succession of pictures showing the gay quarters and the theater.

The woodblock print developed as a popular art in Edo, a city of around one million inhabitants. It found its chief market, not among the bourgeois but among

the common people of the city. The common people looked on the theater and the gay quarters as a means of lending some life and color to their existence, and eagerly sought after the prints of famous courtesans and popular actors of the day. At the same time, there seems to have been a demand for cheap prints on flower-and-bird themes, and *kachō-ga* are already found among prints of the Genroku-Kyōhō eras. Moronobu even produced a book entitled *Kachō Ezukushi*. However, many of the *kachō* prints of this period were produced as substitutes for paintings, and were made up into hanging scrolls and the like. Gradually, the techniques of print making developed to permit the printing of two or three colors from blocks (instead of applying color by hand as hitherto), but this was not enough to permit the realistic portrayal of flower-and-bird subjects, and most of these prints relied for their effect on the powerful effects of line. Okumura Masanobu and Nishimura Shigenaga among others did work in this vein.

The evolution of the *nishiki-e* (polychrome print; traditionally attributed to Harunobu in 1765) brought important developments in the flower-and-bird print. One obvious reason for this was the new ability to produce any combination of colors using blocks, but another was the fact, already mentioned, that the "picture from life" had come to occupy an important part in the world of art generally. All the masters of the early *nishiki-e*—Harunobu and Koryūsai, Bunchō, Toyoharu, Shigemasa, and Shunshō among them—tried their hand at flower-and-bird prints. They succeeded in portraying the brilliance of their subjects in rich, attractive colors. Almost certainly, the citizens who bought their prints stuck them on folding screens and paper doors to brighten up their homes. Utamaro, who worked somewhat later than the artists just mentioned, produced some particularly fine work in this genre. He did comparatively few single-sheet prints of this type but did much work in the form of *kyōka ehon*. His *Shiohi no Tsuto*, for example, is devoted entirely to shellfish. His *kyōka ehon Momochidori* deals with birds, and his *Ehon Mushi-Erami* with, insects, frogs and other small creatures. They are painstakingly faithful to nature and exploit the resources of color block printing to the full, though they have a more literary quality—because of their association, in these works, with verse—than the realistic efforts of Harunobu and his contemporaries.

Another artist who did both prints and paintings of fish and flowers is Kubo Shumman. Masayoshi (Keisai) did albums of flowers, birds, fish, shellfish, and animals rather in the manner of painting manuals, and also produced picture books showing various rare birds imported from abroad. Around the same time (the Kansei Era, 1789–1801) publishers began to put out books on the techniques of flower arrangement (possibly because of the gradual spread of flower arrangement to ordinary households). The ukiyo-e artists did illustrations for these works, and this heightened still further interest in pictures of this type of subject. In short, the ukiyo-e, which had hitherto concentrated on genre subjects, was enlarging its

field of activity to include non-human subjects—flora, fauna and landscapes. This not only indicated a change in the artists themselves; it was also a sign that the average citizen who bought the pictures had developed to the point where he could accept something slightly more spiritual than pictures of actors and prostitutes. In a way, of course, landscapes and flower-and-bird themes were more general in their appeal than the gay quarters and the kabuki theater, and represented an extension of the ukiyo-e's subject matter in response to the increasing demand for prints in the provinces, away from the major cities.

In one sense, the Bunka and Bunsei eras (1804–30) marked the peak of the genre print. Yet at the same time, there was a marked loss of nobility and a sharp increase in the element of grotesqueness and cruelty, designed to pander to the popular demand for vulgar eroticism and "realism." At the same time, culture was permeating right down to the lowest strata of Edo society, giving rise in both literature and art to a vein of vulgar frivolity bordering on the nonsensical. It had its own merits, of course, and the ukiyo-e artists made the most of them. What was really happening was that culture was gradually becoming truly national as the system that had held society in a straitjacket for two or three centuries past gradually disintegrated. The contradictions within the feudal system maintained by the Tokugawa shogunate were becoming increasingly apparent; the situation both at home and abroad was growing more and more tense; and there were increasing exchanges between town and country and between different levels of society.

The newly emerging mass culture led, towards the close of the Tokugawa period, to a growing production of landscapes and flower-and-bird pictures that would please people in the provinces who knew little of life in Edo. The two great artists of this trend were, of course, Hokusai and Hiroshige. Hiroshige in particular produced a very large volume of such work with a very high artistic quality.

HOKUSAI'S KACHŌ-GA
Seen as a whole, Hokusai's artistic life, which accounted for some seventy of his ninety years, presents a variety unparalleled by almost any other artist. He prided himself on being able to depict any subject at all—a pride that seems well justified if one looks, for example, at his celebrated *Sketchbooks*. He did everything—human figures and human society, animals, divine beings, purely imaginary subjects, graphic design, houses, articles of everyday use, and so on: the list is endless. His eye seems to have been unceasingly active, taking note of whatever was about him and sketching, sketching. . . Any plant or animal was a suitable subject for his brush. In an afterword to "One Hundred Views of Mount Fuji," published when he was seventy-five, he declared that it was only at the age of seventy-three that he really perceived how to handle the bone structure of animals

and how to portray flowers and birds as they really were. To make such a declaration, he must have had considerable confidence. At last, he must have felt, the years of study that were designed to enable him to depict anything were at an end.

In his fifties, Hokusai was busy turning out picture books and illustrations. Beginning in that same period, and continuing on into his last years, he produced and published a large number of painting manuals. These manuals—and the great *Sketchbooks* should in a sense be included among them—contain many pictures of flowers, birds, and animals. Quite apart from these, his other work also contained many similar *kachō-ga*. In many cases, artists produced such work solely for their own pleasure, but Hokusai published his, which shows that there was a steady public that purchased his work, either simply to look at or to serve as a model for their own artistic efforts.

Hokusai's single-sheet *kachō-ga* prints include both *ōban* (25 × 38 cm.) and *chūban* (20 × 28 cm.) works, and he also did some works occupying two sheets, joined vertically for mounting as hanging scrolls. The latter were intended as cheap substitutes for the paintings normally hung in the alcove of a Japanese room, but the *ōban* and *chūban* works have a great intrinsic artistic value as prints in their own right. The style is unusually literal for Hokusai; and the flowers and birds are depicted with careful, fine lines. Moreover, they show the same careful attention to seasonal appropriateness in combining birds with flowers or flowers and grasses with insects that Japanese art had always shown. The *chūban* works are given various literary associations by the inclusion of Chinese verse, or of Japanese *kyōka* or *haiku*, but they are unsuccessful compared with the *ōban* works. Besides these prints, there are some very fine *kachō-ga* paintings also. Their subjects include chickens, eagles, various smaller birds, fish, horses, oxen, and sheep, and there is a greater attention to the brush line than in the prints, which raises them to a very high artistic level. They also display subjective elements that remind one of the paintings of Chu Ta of China and give them great interest for the student of the history of the *kachō-ga*. It seems clear that Hokusai considered paintings and prints to be quite separate stylistically and expressed different aspects of himself within them accordingly.

HIROSHIGE'S KACHŌ-GA

From around 1830 on, *kachō-ga* prints for popular consumption began to be turned out in large numbers. Hokusai and Hiroshige were both partly responsible, but, apart from them, other ukiyo-e artists such as Kuniyoshi, Toyokuni, and Eisen all published *kachō-ga* in varying quantities. A possible explanation of the proliferation of flower-and-bird prints at this time is as follows. Since the flowers and birds are painted not in isolation but against backgrounds—or, at the very least, background colors—suggesting the changing seasons, it is necessary to adapt print techniques so that they can conjure up the required mood. We know

that from around 1830 a cheap form of the indigo color so much in use was developed (until then, it had been extracted from old dyed rags). This made it possible to produce skyscapes of a more convincing color; in fact a great deal of the beauty of Hokusai's and Hiroshige's landscape prints, and not only their *kachō-ga*, can be attributed to the use of this new pigment.

Around 1831, Hiroshige published a number of flower-and-bird prints in the *ōtanzaku* form. For the most part these aimed at a *haiku*-like beauty, suggesting the depth and scale of nature with the utmost economy of means and in a very small space. The poetical interest in nature shown by the Japanese sensibility ever since the Nara and Heian periods is very much in evidence, to great artistic effect. Hiroshige, who lost both parents when he was only thirteen, and had to make his own solitary way thereafter, seems to have been affected in his outlook on life by a kind of pervasive, sentimental melancholy, which is as apparent in his flower-and-bird pictures as in his landscapes. It accounted for a large part of his popular appeal—which was very great—and he produced a large number of works of this kind. Hokusai, who lacked this romantic quality of Hiroshige's, seems not to have achieved the same kind of popular success.

Hiroshige's art does not range so far as that of Hokusai, and he concentrated on landscapes, yet in the intervals of such work he also did various kinds of *kachō-fūgetsu* work in many different sizes—*ōtanzaku, chūtanzaku, shōtanzaku, ōban, chūban, koban,* and prints for use on hanging scrolls. Some of the smaller works are of the utmost refinement. Poetical and emotional in his approach, Hiroshige (unlike Hokusai) gave his pictures a focal point around which he arranged his forms and colors, so that the beauty that emerges is not simply that of the subjects themselves but has poetic and atmospheric overtones. Among his *ōban* works there is a set of about twenty prints entitled "Uo-zukushi" in which he devoted much energy to the realistic depiction of fish. This work was originally produced for a group of *kyōka* poets for distribution among themselves, and in this respect resembles the picture books of Utamaro, much money having been lavished on its production. Yet it gives the impression of having had too much care spent on it, and lacks poetic feeling. This latter quality is much more in evidence in the combinations of birds and flowers done in a light, unassuming, sketch-like style which the artist himself seems to have enjoyed more than others.

Hokusai in producing his various kinds of art manuals, had the conscious intention of teaching people his own excellent techniques, but Hiroshige was different. His intention rather was to probe into his own emotional nature polishing his art more and more as he did so; there is nothing that one could really call a "manual" of the *kachō-ga* in his output. Nor did Hiroshige do many paintings; the few that we have are unpretentious and without the expressive power of the prints. One of the few exceptions is a wooden door painting of *yamazakura* ("mountain cherry"). A painting on this scale is rare even in Hokusai's output—

rare, indeed, in late Edo period painting as a whole. It suggests that Hiroshige might have done more large-scale works if only he had had the opportunity, but he was still occupied doing the preliminary paintings for prints when he died at the age of sixty-two in 1858. Hokusai had already died at the age of ninety, nine years previously.

HOKUSAI AND HIROSHIGE

Any comparison of the positions of Hokusai and Hiroshige in the history of Japanese art must necessarily consider the question from many different angles. Very special emphasis however must be laid on the landscapes and *kachō-ga* to which both devoted so much of their energies. Hokusai saw nature as an object outside himself on which he strove to impose artistic form and his landscapes are unparalleled in their scale. The same, basically, is true of his flower-and-bird pictures. He was not interested in how history would see him, being too pre-occupied with giving his own self artistic expression.

It was not so with Hiroshige. All men, by the very fact of being alive, are fated to share joy and sorrow alike. The pictures men paint are an expression of the feelings of all humanity. At the same time, the work of Japanese artists is an expression of the national gifts of the Japanese people as they appear in the nation's long history. In the case of Hiroshige, the artist was of a literary bent and possessed of a rich emotional life. His outlook was enriched by the poetry of the centuries from the time of the *Manyōshū* on; he was particularly familiar with the *waka* composed by the courtiers of the Heian period. Not for him was the objective, material view of nature. He saw nature's colors, forms and moods as expressions of subjective human emotions such as love, joy, and sorrow—an attitude that characterizes the Japanese sensibility not only of the Heian period but of all succeeding ages up to the present. In a sense, Hiroshige gave expression to the national sensibility in terms of birds and flowers. The first blossoming of that national sensibility occurred in the Heian period. To find its closest equivalent in later ages, one would probably have to look to the popular art of the Edo period. The *meisho-e* (pictures of famous scenic places) of the old *Yamato-e* recurred as one of the principal themes of the ukiyo-e, and the *kachō-ga* is likewise a continuation of a tradition dating from the same period, though it is probably correct to say that it was Hiroshige rather than Hokusai who perfected the *kachō-ga* in this sense. Seen in this light, Hiroshige's pictures of flowers, birds and other natural phenomena hold a high place in the history of Japanese art.

Hokusai's Life

THE WORKS of Hokusai presented in this volume represent only one facet of an enormous and varied output. That the output was varied is attributable to the artist's incredible energy and unflagging interest—and to the pleasure he took—in every detail of the world he saw about him. That it was enormous is attributable partly to the same energy, and partly to the fact that he lived and continued to create until a ripe old age. Hokusai died in his ninetieth year. His life extended from just before the appearance of the polychrome print that ushered in the golden age of the ukiyo-e up to a point only a decade or so before the opening of Japan to the outside world.

As with many ukiyo-e artists, our knowledge of the details of Hokusai's life is extremely scanty. In Hokusai's case, however, the core of verifiable fact is surrounded by an unusually large accretion of legend and anecdote. Such an accretion is frustrating, in that one can never wholly accept or dismiss it, yet its very existence points unmistakably to a personality of a scale quite out of the ordinary, and to an influence in the artistic world of the day that transcended questions of personal affinities and rivalries.

Hokusai was born in 1760 at Honjo Wari-Gesui, on the edge of Edo, then a thriving city of some one million and a half inhabitants. His family name was Kawamura, and his personal name in his childhood was Tokitarō. During his long life, he was to become notorious for the frequency with which he changed his artistic pseudonym, but the artistic surname that he used most frequently, the surname by which he is generally known nowadays, is "Katsushika," which is the name of the general area in which Honjo Wari-Gesui was situated. There was something intensely down-to-earth—peasant-like almost, in comparison with his fellow ukiyo-e artists—about Hokusai's outlook throughout his life. Indeed, he referred to himself as "the farmer of Katsushika," and it may not be fanciful to suppose that he chose the name to remind himself of his place of origin.

At the age of three, he was adopted by one Nakajima Ise, a polisher of mirrors in the employ of the Tokugawa shogunate. He himself, however, was destined

not to follow in his adopted father's footsteps. According to various sources, he was already demonstrating an interest in art at the age of five. It was just around this time that the polychrome print first came into being, and for all our lack of knowledge of his earliest years, it seems likely that the new public interest in the form would have stimulated an artistically minded young boy's own ambitions.

Around 1769, he changed his personal name to Tetsuzō. According to one theory, he left the Nakajima household at this time, but the fact remains that for purposes of official registration he continued to use his adopted surname until his death.

Frustratingly little is known about his formative years, though it seems that in his mid-teens he was apprenticed to a woodblock artist. If this is so, it would have given him invaluable experience in the engraving and handling of woodblocks. The first published work associated with him—the book *Rakujo Gōshi*, for which he is said to have done part of the engraving—also dates from this period.

The first clearly discernible landmark in Hokusai's life occurs in 1778, when, at the age of eighteen, he became a pupil of Katsukawa Shunshō, one of the great masters of the ukiyo-e. The years that followed saw him working in a large number of different forms. From around the age of nineteen, he was already doing prints of actors, and they were followed by others depicting beautiful women, sumō wrestlers, and flower-and-bird subjects.

Significantly, he also tried his hand at landscapes—the field in which he was later to do some of his greatest work. More interesting in themselves, perhaps, are the illustrations that he did for the popular literature of the day, especially the type of novelette known as *kibyōshi*. In these, his vitality, his interest in a great variety of subjects, and his vigorous use of line soon enabled him to establish a characteristic style of his own.

Hokusai seems to have won rapid favor with his teacher Shunshō, for it was only one year after he first became his pupil that he was granted the pseudonym Shunrō, incorporating—as custom dictated—one half of his master's own name. Yet for all the variety and promise of his early work, the fact remains that Hokusai was late in maturing, and at the time his teacher died—when Hokusai himself was already thirty-two—he still had to find a secure niche in the artistic world of his day, which was dominated by great masters such as Kiyonaga, Utamaro, and Eishi.

Following the death of Shunshō, the Katsukawa school that he had founded went into a gradual decline. Hokusai, it seems, had already been finding adherence to the traditional style of one particular school something of a hindrance to his development, and his own style showed a considerable degree of eclecticism. The death of the master and decline of the school as a whole must have encouraged him to branch out still further. He associated, for example, with an artist called Tsutsumi Tōrin—who based his style on that of his great predecessor Sesshū—and

actually produced a number of joint works with him. He tried his hand, too, at a number of other different styles, even studying for a while with Kanō Yūsen, a minor member of the official Kanō school of painting.

Hokusai's refusal to conform to any one artistic style may have incurred the displeasure of the leaders of the Katsukawa school following Shunshō's death. On the other hand, trouble may have been caused by what appears to have been a powerfully individualistic personality. Whatever the cause, however, it is a verified fact that in 1794, when he was thirty-four, he was expelled from the Katsukawa school and found himself alone. He had produced quite a large and varied amount of work, but none of it had made any particular mark. He was still "promising," but that was all.

However, he still had a long life ahead of him; nor was a new chance long in presenting itself. For three years, from 1795 to 1798, he became head of a school founded by one Tawaraya Sōri (a name chosen by the artist; "Tawaraya" was the surname of the great Sōtatsu) and devoted to reviving the tradition of the Kōrin school. Sōri I had left no one to carry on his newly founded line, and Hokusai, an outsider, took the name "Sōri II." At the same time, he accepted as his pupil a young boy, a descendant of Sōri I, and undertook to teach him until he was old enough to take over the name himself.

It was during this period that Hokusai achieved one of his first considerable successes, with a series of *bijin-ga* ("pictures of beautiful women") that filled the gap in the ukiyo-e world of the day (the greatest masters of the genre were by now already dead or past their prime) and became popular under the name of "Sōri Beauties." Doubtless the social security of his new position also gave him a new confidence, and he expanded the range of his activities considerably. In his prints, he was showing a new interest in landscapes, which he executed with an eye for detail and strength of line derived, doubtless, from his studies of the "Chinese" style. He was also doing illustrations and work for picture books; notably, he was beginning to do excellent work for the *kyōka ehon*, the books of humorous verse with pictures, which were so popular at the time. A typical example is *Azuma Asobi*, which showed scenes of life in Edo with romance and humor, in a vigorous style showing distinct Chinese influences.

One year after relinquishing the title of Sōri II, Hokusai reached the age of forty. The three decades that followed were to see him produce an almost bewildering array of work, much of it of the highest quality. It is not possible here to give a chronological account of his achievements during this period; it is better, perhaps, to try to classify them into general categories.

Many Japanese artists had been making attempts to apply the newly learned Western techniques of perspective, chiaroscuro, and shading, but in most cases their attempts did not go beyond superficial imitation or a desire to catch the popular eye with novel effects. Hokusai, however, succeeded in assimilating them

and using them in a creative manner. This is apparent in print series such as *Ōmi Hakkei* ("Eight Views of Ōmi") and *Edo Hakkei* ("Eight Views of Edo"), as well as in paintings such as *Ushigafuchi in Kudan* and in his woodblock prints.

He continued his work with the *kyōka ehon*, especially during the first part of the period. These books—which, using as they did a large number of colors, were quite extravagant examples of their type—concentrated especially on the city of Edo and its inhabitants, together with scenes on highways such as the Tōkaidō, which led from Edo to the Kansai district.

During the first half of the three decades of his maturity, Hokusai continued doing illustrations for works of popular literature, such as the tales of Takizawa Bakin. These tales, with their extravagant flights of fancy, gave plenty of scope for the strong streak of interest in the picaresque, and even the grotesque, that ran through Hokusai's character. In time, however, the number of illustrations he did began to be reduced, and polychrome prints began to take their place.

During the latter half of the three decades in question, Hokusai's interest in book illustration seems to have waned, and he produced an increasing number of "manuals" of painting and drawing. Within this category—though of course they far transcend any purely instructive role—fall his celebrated series of *Sketchbooks*, which began in 1814 and ended around 1819. It is in these works that one sees most clearly Hokusai's astonishing powers of observation, especially of the human race, which he viewed with a characteristic blend of detachment and compassionate humor.

He also continued to turn out the brush paintings that appear sporadically throughout his whole output. Among them were such well-known masterpieces as "Beauty in her Cups" and "Gathering Shellfish at Low Tide."

All the while, his prints were exploring the possibilities of the landscape. A comparatively early (1804) "Fifty-three Stations on the Tōkaidō" was followed in rapid succession by other series, and he continued to do landscapes throughout the following years. Parallel with this, he produced a wide variety of flower-and-bird prints of varying sizes.

It was at the end of the period, however, when he was already in his sixties, that he started work on his great masterpiece, the "Thirty-six Views of Mt. Fuji." A series of forty-six *ōban* prints (ten additional prints were made after the originally planned series was completed), it is remarkable for its variety and inventiveness, and includes two works in particular—the "Red Fuji" and the "Great Wave off Kanagawa"—that by now are known all over the world.

In the course of the period that culminated in the "Thirty-six Views," Hokusai gradually emerged as the preeminent figure in the world of ukiyo-e of his day. He stood apart from the rest, not only in the superiority of his art, but also in its freedom from the vulgarity that was affecting so many other ukiyo-e artists. It was different, too, in that it was never completely of and for Edo—so completely

urbane—as that of most of his contemporaries, but always retained something refreshingly rustic and down-to-earth.

The man himself, too, seems to have stood somewhat apart from his fellows. We have little verifiable knowledge about his personal life, yet it is apparent from anecdote that he was no ordinary man. He is said, for example, to have changed his place of residence ninety times. We know that at one time he seemed to be living in comparatively prosperous surroundings with many pupils. But we know, too, that the pupils deserted him as he grew older. His enormous vitality and interest in everything he saw about him is witnessed not only by his work as such, but by occasional writings of his that show that the vitality and interest—as well as ambition for the future—persisted into old age. It seems, too, that the iron will, the confidence, and the powerful ego that one senses in his work made themselves apparent to his contemporaries also, and that he was in many ways a solitary figure. He corresponds, in short, to a human type that is to be found among great artists the world over.

Although it seems certain that publication of the "Thirty-six Views" continued into Hokusai's seventies, it was by no means the last of his notable productions. Prints series and picture books that he published in his seventies also include such fine works as *Shokoku Taki Meguri* ("Waterfalls Throughout the Country"), *Ryūkyū Hakkei* ("Eight Scenes from the Ryukyus"), and *Shokoku Meikyō Kiran* ("Unusual Views of Famous Bridges Throughout the Country"). He also did a number of works with flower-and-bird themes.

Nevertheless, he never again attained the peak of achievement that is represented by the "Thirty-six Views." In part, of course, this fact is attributable to simple old age. It also seems likely, however, that it was due in part to a loss of self-confidence in his hold on the public. Hiroshige's star had been rising at a rapid rate; the gentle romanticism of his work and its lack of forbiddingly intellectual qualities seem to have appealed to a public long accustomed to the sterner climate of Hokusai's art.

Hiroshige's reputation finally became unshakable in 1833, when Hōeidō published his famous "Fifty-three Stations on the Tōkaidō." It was followed only a year later by Hokusai's own "Hundred Views of Mt. Fuji," which gives the impression of having been published in an attempt to counteract the popularity of Hokusai's rival. Be that as it may, the work itself is of high quality. A series of prints in book form using only black Chinese ink with various gradations of shade, it achieves some very poetic effects and maintains a high level of invention. But it was Hokusai's last important work, even though there was much attractive material among the flower-and-bird prints he published at about the same time.

The years that followed represented an unmistakable decline. He did many illustrations, often on Chinese, historical, or Buddhist themes, and a number of prints on genre subjects, but their technical skill was not enough to give them a true

popular appeal. More successful among the works of his last years are a number of brush paintings that he seems to have done chiefly for his own pleasure. He continued to travel—he undertook a long trip to northwest Honshu at the age of eighty-six—and he published a manual of painting at the age of eighty-nine in which he announced his intention of living until he was over one hundred. But he died the next year, on the eighteenth of the fourth month, 1849.

He was survived by his younger rival, Hiroshige, for a mere nine years. There were other artists who produced fine work in the field of landscapes and flower-and-bird pictures (Kuniyoshi, for example), but the social changes brought about by the Meiji Restoration, the introduction of the camera, and various other factors combined to inhibit the appearance of any true successors of equal rank.

Hiroshige's Life

ALTHOUGH Hiroshige was born a full thirty-seven years later than Hokusai, he survived him by only nine. The names of the two men are inextricably linked in the history of Japanese art, most notably as the two masters who perfected the landscape in the ukiyo-e print, but also for the outstanding work that both, with their widely differing temperaments, did in the field of the flower-and-bird picture.

In its sheer power and range, Hokusai's art was the more comprehensive. Landscapes and flower-and-bird pictures account for a far greater proportion of Hiroshige's total output than they do in that of Hokusai. Hiroshige's genius—as he seems to have realized—was not suited to the production of pictures of beautiful women and warriors, nor to picture books and illustrations for popular literature. Hokusai, on the other hand, did some of his finest work in these fields.

Emotionally, too, a great difference is apparent between the two men. Hokusai's work is subjective only in the sense that everything he depicts is infused with his own great vitality; the composition is dominated by his own powerful intellect, and his work often seems to be about to leap into movement, or to be a capturing of one particular, dynamic moment in time as experienced by the artist. His use of color, although it can be highly effective, is often more symbolic than atmospheric. Hiroshige's work, on the other hand, is romantic, evocative, and poetic; many of his landscapes and flower-and-bird pictures summon up a mood that is deeply imbued with the artist's own sensitive, compassionate personality. Both men are deeply human, but Hokusai's humanity is more robust and dynamic, whereas Hiroshige's is more resigned and melancholy.

To some extent, perhaps, the melancholy quality can be traced to Hiroshige's personal life. Economically, he was at no stage reduced to the dire straits that afflicted Hokusai—who at one time was reduced to peddling wares about the streets of Edo—yet sadness struck him frequently in his personal relations. His mother, of whom little is known, died suddenly in 1809, and his father died in the same year, leaving him an orphan at the tender age of thirteen. His first wife

died in 1839, when he was forty-three. Two years later, his only son Nakajirō gave up the hereditary family occupation of fire warden and only four years later died in his turn. Hiroshige married again, to a seventeen-year-old peasant girl, but even this marriage was marred by a scandal involving his new wife's brother, a Buddhist priest.

His father, Andō Genemon, was a fire warden living in the Yayosugashi district of Edo, not far from Edo Castle and close to the present site of Tokyo Station. The post of fire warden, which was not unimportant in a crowded wooden city such as Edo, was hereditary, and carried with it, if not wealth, at least freedom from the economic distress that affected other ukiyo-e artists in their early lives.

Hiroshige himself was born in 1797 and given the personal name of Tokutarō. We know little of any early interest he may have shown, or instruction he may have received during his childhood. However, it is known that Okajima Rinsai, the man who taught him the style of the Kanō school, was at one stage a part of the Andō household (he also was a fire warden) during Hiroshige's childhood, and it seems likely that he would have given young Tokutarō some instruction in the rudiments of painting. What is certain, at least, is that by the time the youth first came to study formally under a teacher he was already possessed of considerable skill, and that there are abundant signs of a Kanō influence in, for example, his use of line.

On the death of his father, Tokutarō—at the tender age of thirteen—formally took over his duties as fire warden. He was obviously not particularly interested in the post, but it was necessary to keep it in the family at least until he could decently pass it on to another member. Two years later, in 1811, he became a pupil of Utagawa Toyohiro, a member of the Utagawa school that was one of the most important influences in the ukiyo-e at the time. He must have been an apt pupil, for he had only been studying with his new teacher for one year when, at the age of fifteen, he was granted the right to use the surname Utagawa and given the new personal name of Hiroshige.

His formal studies with Toyohiro ended after the first year, and after this he seems to have spent some time enlarging his artistic experience by studying the styles of schools other than the Utagawa school. This included further work with the style of the Kanō school, which was one of the "official" schools of painting under the Tokugawa shoguns and was heavily influenced by Chinese art and Confucian ideas. He also experimented with the Nanga style, receiving instruction from Ōoka Umpō, who was himself a pupil of the celebrated Tani Bunchō. There is also an obvious influence from the Shijō school, which specialized in realistic portrayal from nature.

More important still, perhaps, was the influence of Western art, which around that time was beginning to have a considerable effect in Japan, especially where naturalistic techniques and the use of perspective were concerned.

Despite Hiroshige's obvious promise, it was some time before he really found his feet as an artist. Much of his time in his late teens and on into his twenties was spent in turning out pictures of beautiful women and warriors, and in doing book illustrations. In these fields, however, he had formidable rivals in men such as Kunisada, Kuniyoshi, and Eisen, while the field of the landscape print was still dominated by the great Hokusai. His own work, moreover, was not at its best in the former three fields—he never, for example, succeeded in striking the right note of sensuality that the Edo public was increasingly demanding in its *bijin-ga*.

At the age of twenty-seven, Hiroshige handed over his post as fire warden to his cousin Tetsuzō, and from then on devoted himself exclusively to his art. During the next years, he seems to have been debating the course his art should follow henceforth. Gradually, the number of "beautiful women" in his output decreased, and finally in 1830, when he was thirty-four, he seemed to reach a crucial turning-point in his career. He resolutely abandoned his attempts to rival other artists in the fields of *bijin-ga* and warrior pictures, and instead set about developing a truly individual style in his landscapes and flower-and-bird pictures.

With remarkable speed, his flower-and-bird pictures acquired a new freedom of form and a new and more personal use of color. Although they were not yet fully mature, they had at least gone beyond the stage of imitation. The same process took place with his landscapes. The most remarkable indication of the change, and one of Hiroshige's first really important works, is the *ōban* series "Famous Places in the Eastern Capital," which, though not completely mature, marks a definite advance over anything that had gone before in its use of both line and color, and in a new and apparently more affectionate approach to both nature and man.

The two years between 1830 and 1832 seem to have given Hiroshige a new confidence, and also to have marked the beginning of his popularity with the general public. From now on, his development, as marked by the best works among his output at any given time, was steady. It was in the years succeeding this new and maturer phase of activity that he produced some of his finest flower-and-bird pictures. Unpretentious though they may seem, they effectively sum up something in his attitude to nature—a romantic warmth, an unemphatic solicitude—that was to characterize all the best work of his later years and to set him off so clearly from Hokusai. He also extended the scope of the flower-and-bird picture by producing, in the same vein, a charming series of realistic pictures of fish—a great novelty in the ukiyo-e.

Hiroshige had a passion for travel, and during the latter half of his life was constantly making trips to one part or other of the country, trips that took him, sketchbook in hand, along most of the highways that linked the provinces of feudal Japan. Artistically, these journeys were to prove invaluable for him. They were made at a time when the people of Edo were gradually becoming more aware of

the nation that lay beyond the confines of the capital, and when a new interest in travel—or if not in travel, in seeing in pictorial form the sights that other provinces and cities had to offer—was gripping the inhabitants of the larger towns.

The first major fruit of his peregrinations was the celebrated "Fifty-three Stations on the Tōkaidō," a series of horizontal *ōban* prints based on a journey along the Tōkaidō, the most celebrated highway of all, that led from Edo to the imperial capital of Kyoto and to Osaka. Work on the series began after his return to Edo, using the sketches that he always made wherever he went, and it was completed in 1834. Numbering fifty-five prints in all, it was published by Hōeidō.

The series took Edo by storm. Overnight, Hiroshige became the idol of the print collector (and, in effect, ousted the aging Hokusai from the position that he had held securely for so long). In its variety of subjects, composition, coloring and—above all—lyricism, the prints were like nothing the public had seen before.

In the next few years, Hokusai produced a great deal of first-rate work. The "Eight Views of Ōmi," a set of eight prints modeled, as were so many other works, on the "Eight Views of Hsiao-hsiang" of ancient China, showed scenes on and around Lake Biwa, in the Ōmi district, for which Hiroshige seems to have had a particular fondness. Another fine work almost contemporary with the Ōmi series is a set of ten prints entitled "Famous Places in Kyoto," which doubtless aimed to take advantage of the growing interest of the people of Edo in the other cities of Japan. A similar aim probably inspired another set, "Famous Places in Naniwa," which dealt in much the same way, though less successfully, with the city of Osaka. Nearer home, Hiroshige did various other series showing Edo and its environs; they include some of his very best work.

The next major landmark in Hiroshige's life came around the age of forty, when he started work on a series of prints showing scenes on the Kiso highway, the road that led from Edo to Kyoto, not along the coast as did the Tōkaidō but over a mountainous inland route. The work, entitled "Sixty-nine Stations on the Kisokaidō," was clearly prompted by the tremendous success of the Tōkaidō series, but there is considerable confusion as to its origins. It appears that it was first undertaken by Eisen, and that after publication was already under way Hiroshige joined with Eisen, but subsequently undertook sole responsibility for the remainder of the series in Eisen's stead. Another intriguing aspect of the set is that it also changed publishers in midstream, becoming first a joint venture between Hōeidō, the original publisher, and Kinjudō, then finally the sole responsibility of the latter.

Whatever the circumstances surrounding their production, however, the forty-five prints for which Hiroshige was responsible contain some very fine work. The prevailing atmosphere, it is true, is far gloomier than that of the Tōkaidō series, yet there is some wonderful evocation of mood, and the series shows a remarkable affection for, and knowledge of, the lives of people living in the remote country

districts. Possibly the subdued tone of Hiroshige's contribution was a result of personal sorrow, for it was in 1839 that he lost his wife, in 1841 that his son gave up the family occupation, and in 1845 that that son, too, died.

Another very fine work, the "Eight Views of the Edo Environs," was apparently produced while work was still in progress on the Kiso highway series. From now on, however, Hiroshige seems to have suffered from excessive pressure from his publishers to produce new work. He turned out a large number of new series, some covering, geographically, much the same ground as earlier sets, and in the late 1840's and 1850's traveled widely throughout Japan in search of new material. Inevitably, however, the quality of his work suffered, and mingled with fine pieces there is a distressing number of pieces of mediocre inspiration.

Despite this, during the last decade of his life he was, beyond all doubt, preeminent in his field. Nor did he fail to produce occasional masterpieces that equaled—surpassed, even—the best of his earlier output. Among them must be classified three works that came right at the close of his life: the triptychs entitled "Whirlpools at Naruto," "Moonlight at Kanazawa," and "Mountains and River Along the Kisokaidō."

Hiroshige died of cholera in the ninth month of 1858, at the age of sixty-two. We can never know what masterpieces he might have produced had he lived on and acquired the leisure to concentrate more exclusively on the kind of work his artistic conscience dictated. Yet though fate decreed that his life should be nearly three decades shorter than that of Hokusai, that life produced enough art of the highest level to ensure him a place alongside his rival as one of the two greatest masters of the Japanese landscape and the flower-and-bird picture.

Works of Hokusai

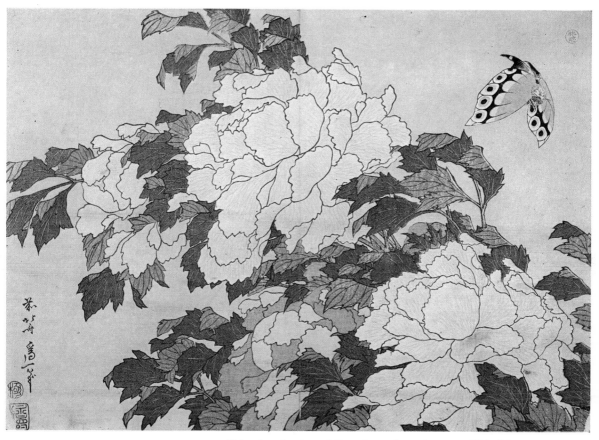

1. *Hokusai* ◆ *Peonies and Butterfly* ◆ *ōban yoko-e* ◆ published by Eijudō ◆ Tokyo National Museum ◆ It is late spring, with violet-tinged clouds trailing in the blue sky above, and the garden below green and fresh with new foliage. The elegant blooms of the peonies sway in the breeze, and a colorful butterfly flutters down over them —what scene could be more relaxed and peaceful? In a more leisurely age, to spread a mat by the peonies and sit in the shadow of the blossoms, sipping saké, was one of the greatest pleasures that life had to offer.

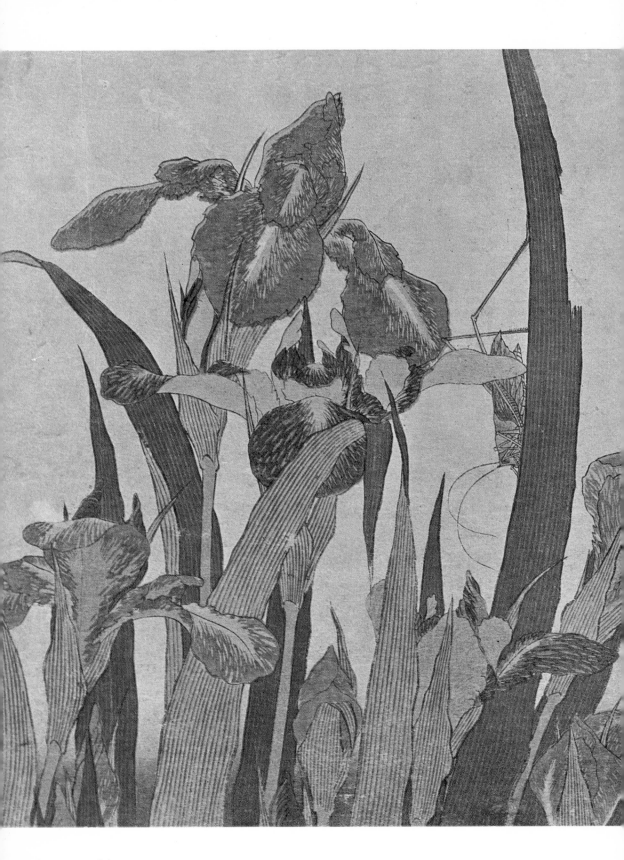

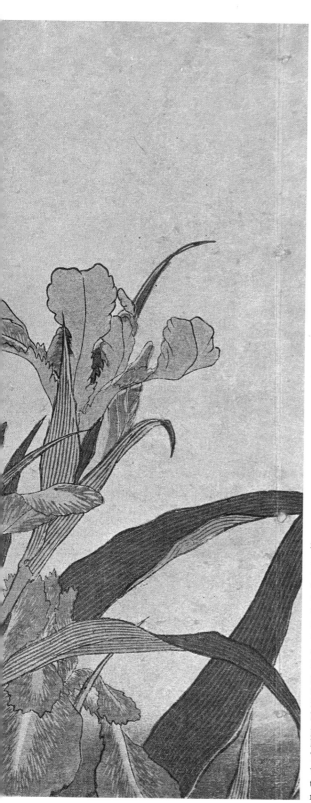

2. *Hokusai* ◆ *Irises (detail)* ◆ *ōban yoko-e* ◆ published by Eijudō ◆ Tokyo National Museum ◆ The nature studies that Hokusai did in the *chūban tate-e* form frequently show the influence of Chinese painting of Ming and Ching times, and sometimes have a literalness that suggests botanical study. However, his works in *ōban yoko-e* form are more traditionally Japanese, being characterized by their lyrical and decorative qualities, and by the great originality and inventiveness in his use of the brush. This picture of irises is one of the finest in the latter category. The work lacks the brilliant coloring of the famous decorative painting of irises by Kōrin, but on the other hand there is a delicacy of line rare in Hokusai. The color scheme is faithful to life, and the work shows certain elements of the decorative that take full advantage of the woodblock medium.

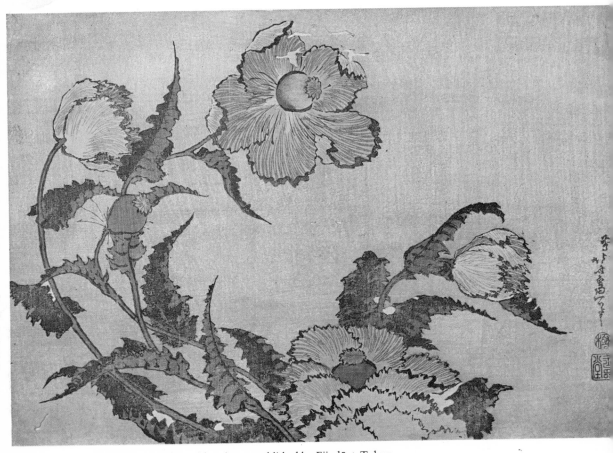

3. *Hokusai* ◆ *Poppies* ◆ *ōban yoko-e* ◆ published by Eijudō ◆ Tokyo National Museum ◆ The rendering of the petals of the poppies is unlike any found elsewhere in Hokusai's work, bearing a remarkable resemblance to lines done with a pen. Around the time when Western-style pens were first introduced into Japan, certain artists painting in the Chinese (Nanga) style experimented with pointed brush tips in order to achieve a "Western" effect, and this picture suggests a similar preoccupation.

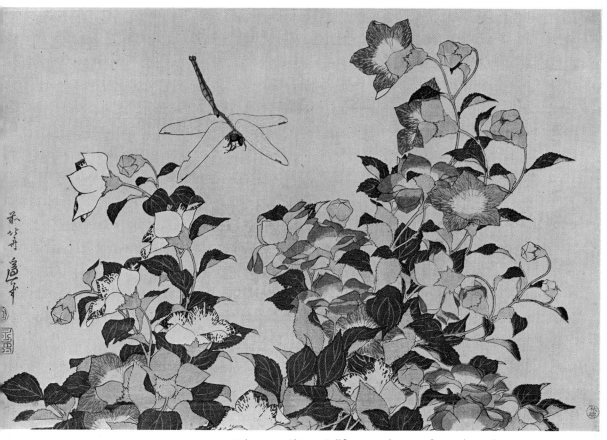

4. *Hokusai* ◆ *Chinese Bellflowers and Dragonfly* ◆ *ōban yoko-e* ◆ published by Eijudō ◆ Tokyo National Museum ◆ The *kikyō* (Chinese bellflower), with its charming blue and purple blossoms, has long been beloved of the Japanese. In the traditional list of the "seven flowers of autumn," it sometimes replaces the morning glory. It appears in some of the oldest known *Yamato-e*; for example, it is depicted along with *karukaya* (a kind of pampas grass) and patrinia in the pictures painted beneath the text in the famous "Fan-shaped Sutras" of the twelfth century. In the Edo period, too, it was a favorite subject for flower-and-bird pictures.

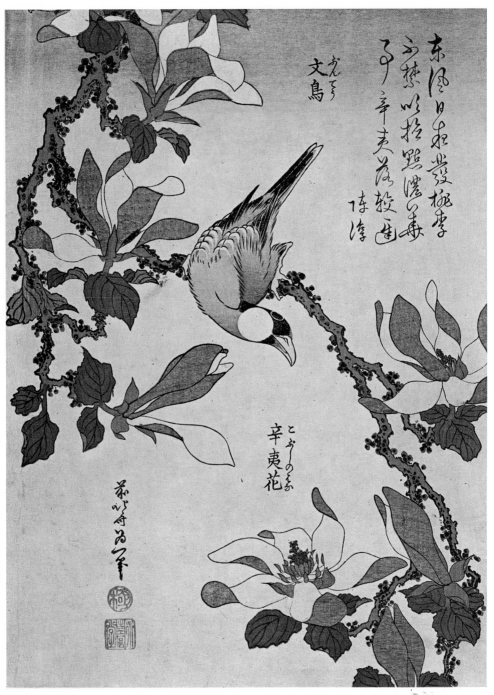

5. *Hokusai* ◆ *Java Sparrow and Magnolia* ◆ *chūban tate-e* ◆ published by Eijudō ◆ Tokyo National Museum ◆ The *bunchō* (Java sparrow or paddybird) is no longer found in Japan except in cages. The magnolia (*kobushi*) blossom is an attractive sight in early spring, twisting its petals upwards from the bare branches on which it flowers. This particular combination of bird and flowers seems to have no special significance. The Chinese verse inscribed at the top right praises the flowers of the *magnolia*, but makes no mention of the *bunchō*. Hokusai's characteristic skill is apparent in the way he captures the position of the bird's body at the moment it alights on the branch.

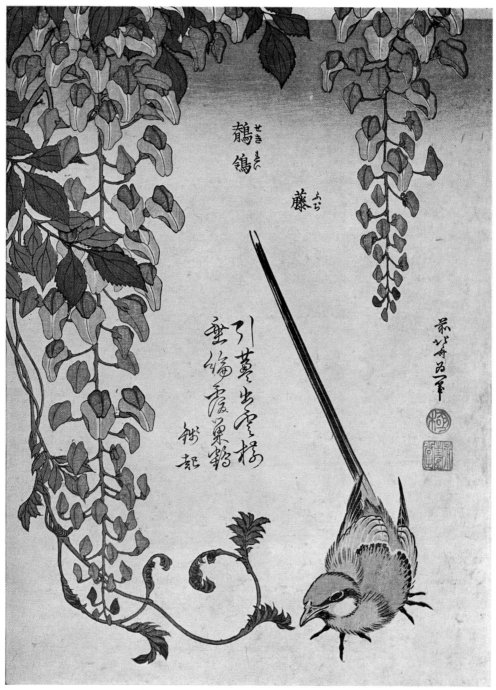

6. *Hokusai* ◆ *Wisteria and Wagtail* ◆ *chūban tate-e* ◆ published by Eijudō ◆ Tokyo National Museum ◆ This author once spent a summer in a house near the dried-up bed of a river. Getting up early and keeping a close watch on the pond in the garden, I found that the first bird to awake and start singing was the sparrow. However, it was closely followed by the wagtail, which did not sing but came flying swiftly and airily from the direction of the river and hopped about on the rocks around the pond, its tail dipping busily as it went. Perhaps it was a desire to emphasize this characteristic that made Hokusai exaggerate the length of the tail. Either way, the long rising tail admirably balances the long clusters of colorful wisteria blossoms, and the picture is one of the most agreeable in the series.

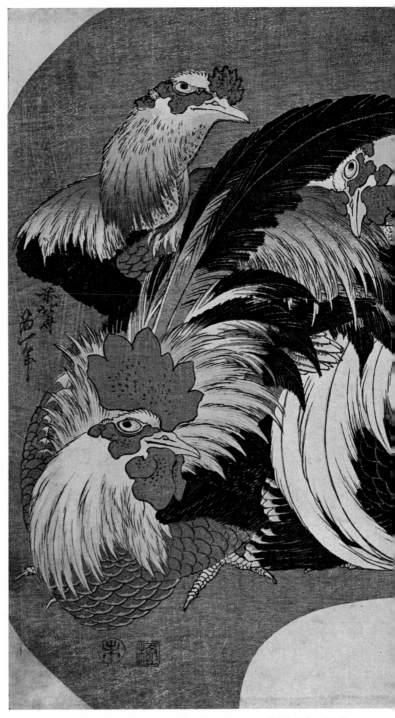

7. *Hokusai* ◆ *Domestic Fowl* ◆ fan print ◆ published by Tsujiyasu ◆ Tokyo National Museum ◆ The seal at bottom left, bearing the character for sheep from the twelve Chinese zodiacal signs, suggests that this work may have been done in 1847, which was a "Year of the Sheep." Seven fowl—cocks and hens together—are arranged in a colorful pattern within the restricted space afforded by the face of a round fan.

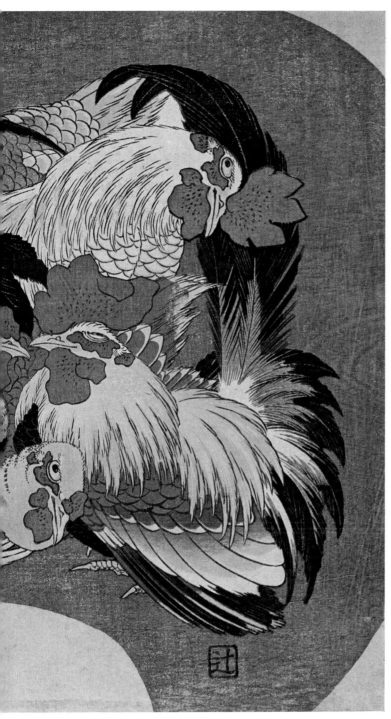

Hokusai, who also did other fan prints of chickens, seems to have been interested in the depiction of feathers. As this work shows, he was not so much interested in extracting poetry from his flowers and birds as in setting down faithfully their forms and movement. This kind of picture was probably thrown away after the fan had yielded one summer's use.

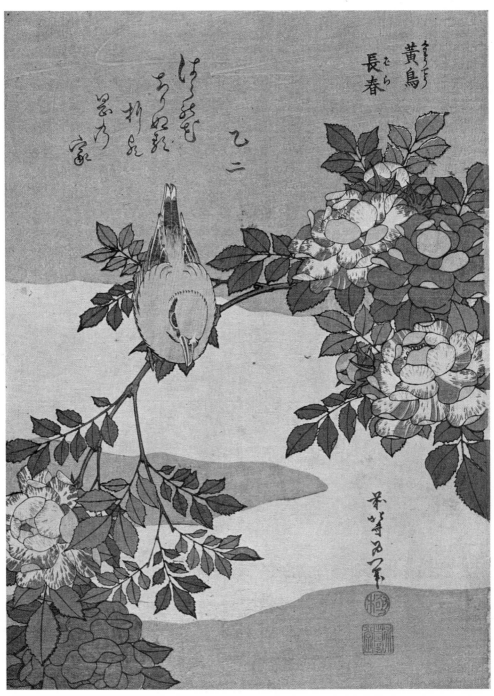

8. *Hokusai* ◆ *Roses and Uguisu* ◆ *chūban tate-e* ◆ published by Eijudō ◆ Tokyo National Museum ◆ The *uguisu* (often referred to as the "Japanese nightingale," though actually a bush warbler) likes to come and perch on plum trees in the garden in early spring, or to pose obligingly on the branches of early blooming roses. The position of the leaves at the end of the branch in this picture, some of which have their backs showing, suggests that Hokusai wished to capture the moment at which the bird alighted on the branch, setting it swaying. The background is very simple; the layer of white cloud, lying like a piece of thin silk against a blue sky, suggests the atmosphere of spring.

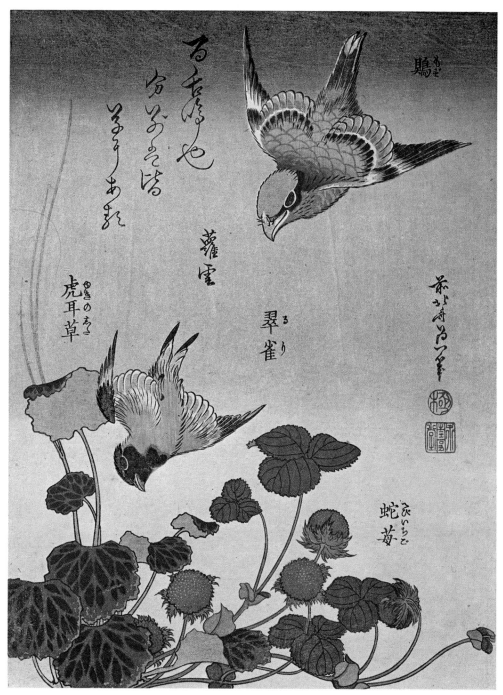

鵙　　翠雀　る　り　蛇苺　へびいちご　虎耳草　ゆきのした　葍　雲

9. *Hokusai* ◆ *Saxifrage and Shrike* ◆ *chūban tate-e* ◆ published by Eijudō ◆ Tokyo National Museum ◆ The shrike, a predatory carnivorous bird, is shown chasing a smaller bird known in Japanese as *ruri*. The latter is seeking to take cover among the creeping saxifrage and false strawberry that grow in profusion in swampy areas. Possibly the two birds are quarreling over the right to the fruit. The long, graceful tendrils of the saxifrage (which account for its popular English name, old-man's-beard) are a subtle touch that plays a major part in the artistic effect of the whole.

43

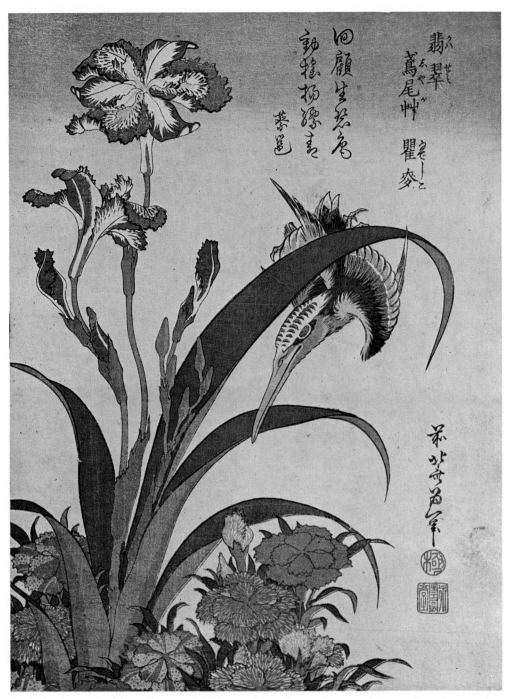

久 翡
し翠
や鳶
が尾
　艸
そ瞿
ー麥
と

回
顧
生
添
庵
釦
稚
揚
碟
壽
藥
邕

10. *Hokusai* ◆ *King fisher, Shaga, and Pinks* ◆
chūban tate-e ◆ published by Eijudō ◆ Tokyo
National Museum ◆ The effect of the *kachō-ga*
depends to a great extent on the quality of the
colors used. Hokusai's *chūban tate-e* prints generally
have strong colors, which convey a feeling of
immediacy and suggest influence from the nature
studies of Ming and Ching China. The treatment
of the *shaga*, a member of the iris family peculiar
to Japan, is especially skillful. The rather odd posi-
tion of the kingfisher's body gives the picture life
and movement.

44

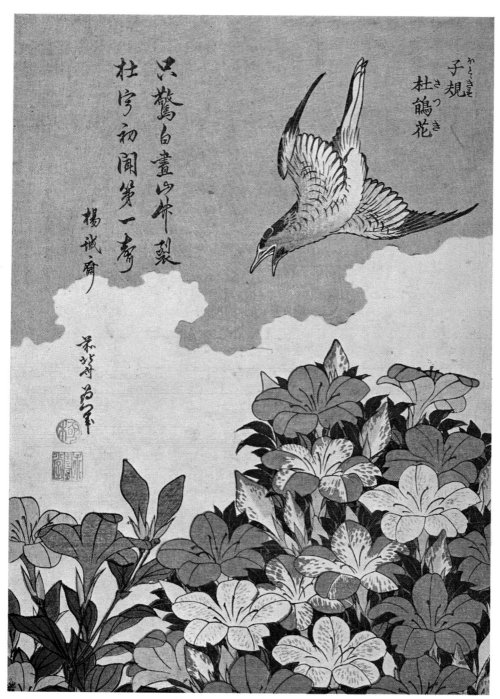

只驚白盡山神裂
杜宇初開第一聲

楊誠齋

子規
杜鵑花

11. *Hokusai* ◆ *Azaleas and Cuckoo* ◆ *chūban tate-e* ◆ published by Eijudō ◆ Tokyo National Museum ◆ The studies in this series all have Chinese poems or *haiku* appended, yet they do not quite succeed in evoking the poetic atmosphere that Hokusai doubtlessly hoped for. Possibly the fount of poetic inspiration was drying up in the old man of seventy. In Japan, the time of year when the azalea bushes are covered with brilliant pink, red, and white flowers is also the season of the cuckoos, call. (The kyo-kyo-kyo-pee-pee of the Japanese little cuckoo, or *hototogisu*, is a cry quite different from its Western counterpart.) The poem tells how the cuckoo flies up into the heavens until it is invisible and only its cry lingers on the air, but Hokusai choses here to depict it in closeup.

45

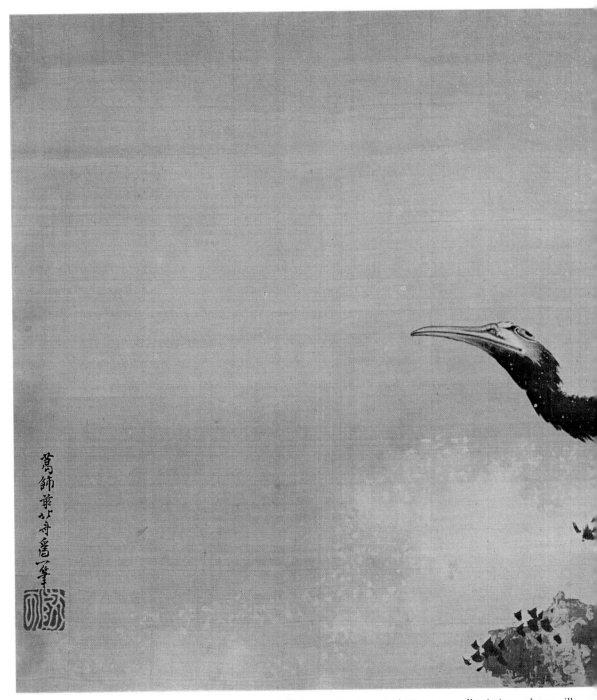

12. *Hokusai* ◆ *Cormorant in the Snow* ◆ scroll painting, color on silk ◆ Okayama Art Museum ◆ From ancient times on, a considerable number of paintings and poems were inspired by the cormorants kept for catching fish, or by the lives of the fishermen who kept them. For men of leisure, to sit in a roofed boat with red lanterns hanging from its eaves and to tipple saké while watching the fisher-

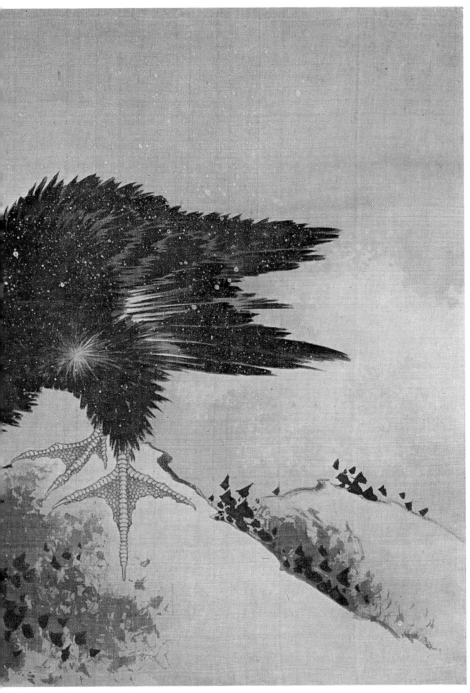

men at work by night with their flares was long one of life's more subtle pleasures. Here, the cormorant is shaking itself to smooth out its wet feathers. One wonders what it is watching so intently in the snow; or what was Hokusai's aim in portraying this solitary bird, alone and free. Whatever the case, the bird quivers with life from the tip of its beak to the ends of its feathers.

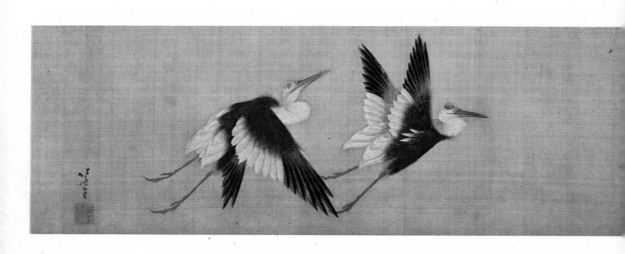

48

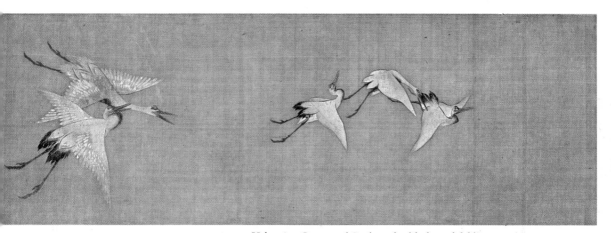

13-14. *Hokusai* ◆ *Cranes and Storks* ◆ double-leaved folding screen, color on silk ◆ Takeo Ujiie collection ◆ Storks haunt swamps close to the hills, where they live on fish and shellfish. They fly at medium height, emitting sharp cries through closed beaks, and nest on roof ridges and the uppermost branches of trees, but now they are almost extinct in Japan. The storks on the left, with their bald heads and necks and piercing stare, might almost be caricatures of the fiercely individualistic artist himself at the age of fifty. On the right, five cranes fly off in oddly contorted positions, almost as though being driven by the storks. The surface has suffered with time, but the delicate coloring is still fresh and alive. There is a suggestion of self-mockery and satire, something virile and assertive, about the way Hokusai tackles his subject, that is different from the Hokusai of later years.

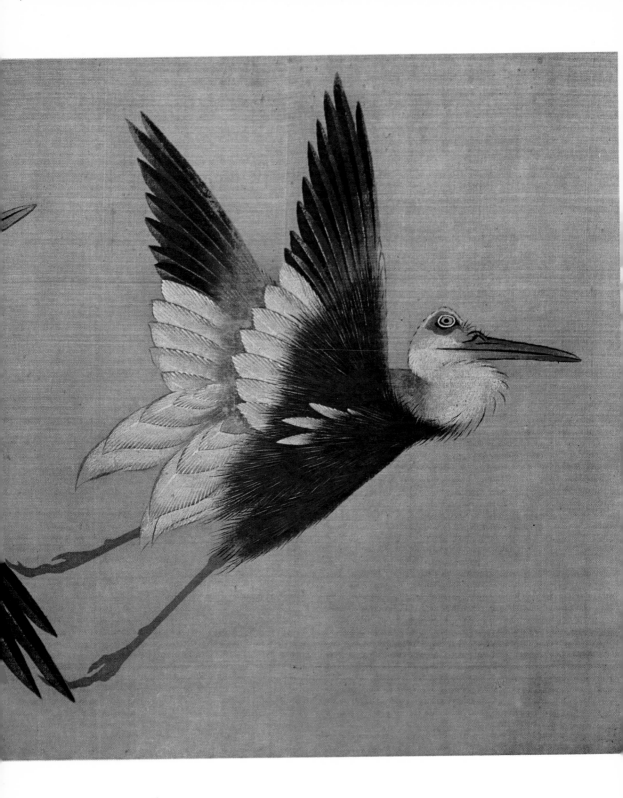

15. *Hokusai* ◆ *Fighting Cock and Hen* ◆ scroll painting, color on silk ◆ Atami Art Museum ◆ One of the *awasemono* ("matching things together") that were popular pastimes in the Heian period (794–1185) was *tori-awase* ("bird matching"), which was nothing more nor less than cockfighting. Mostly, it was a kind of ritual associated with the third day of the third month, when it was regularly performed in front of the Seiryōden hall of the Imperial Palace in Kyoto. The type of fowl known in Japanese as *shamo* was commonly used for cockfights because of its intrepid appearance and quarrelsome nature. There is a well-known picture by Miyamoto Musashi (based on an earlier Chinese painting by Mu Chi) that shows an old man watching two cocks kicking at each other with their spurs, but this scroll painting by Hokusai must also rank as one of the finest works on the theme ever produced. Even the bamboo leaves hanging down at the top of the picture have a stiff, spiky appearance that seems to mirror the birds' nature.

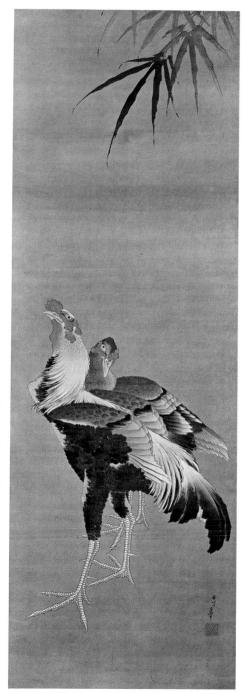

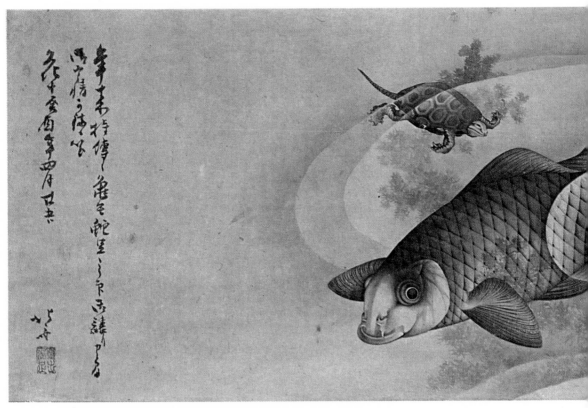

16. *Hokusai* ◆ *Carp* ◆ scroll painting, color on silk ◆ Akira Naka-yama collection ◆ In the inscription on the left of the picture, Hokusai states that he is bequeathing the seal seen in red below the inscription to one of his pupils, who received the picture as a token of this act. The pupil in question was Hokumei, and the date given is the twenty-fifth of the fourth month of 1813. The picture ostensibly shows two carp and two turtles swimming amongst the waterweeds, yet the expressions on the faces of the carp are remarkably human. One cannot avoid the impression that it is Hokusai himself who looks out at his pupil in the guise of these fish. And if one remembers that this work is from the same period as the *Sketchbooks* and much other work of unparalleled vigor, it would not be surprising to find the artist projecting himself into and dominating his subject even in a work such as this.

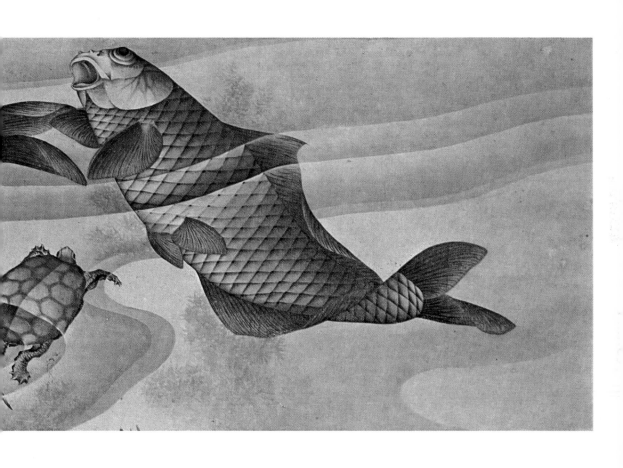

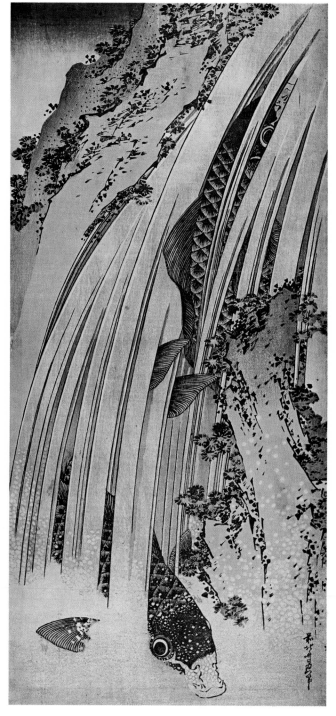

17. *Hokusai* ◆ *Carp in a Waterfall* ◆ scroll print ◆ Tokyo National Museum ◆ The popular theme of carp climbing a waterfall dates back to ancient China, where a well-known legend told how any carp that succeeded in climbing the famous falls at a point called Dragon Gate on the Yellow River would be transformed into a dragon. Thus the carp became a symbol of worldly aspiration and advancement. This type of print was produced as a cheap substitute for the more expensive scroll painting. Cheap or not, the work has a vigor and power worthy of Hokusai's last years.

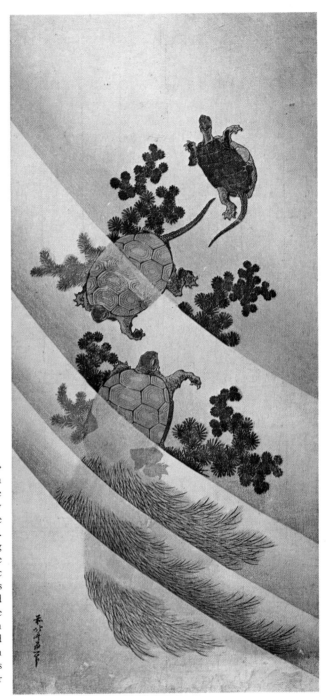

18. *Hokusai* ◆ *Turtles in the Water* ◆
scroll print ◆ Tokyo National Museum
◆ Chinese paintings of fish done in the
Ming and Ching periods often show
objects on and below the surface of the
water in one and the same picture.
Although Japanese paintings showing
the influence of Chinese art of these
periods—the Nanga school and realistic
studies from life—seldom imitate this
device, Hokusai was particularly fond
of it. Here, he skillfully captures the
movements of the turtles as they swim
among the waterweeds, and all his old
powers of observation are apparent in
the variation in the color of their shells
caused by the incidence of light under
water.

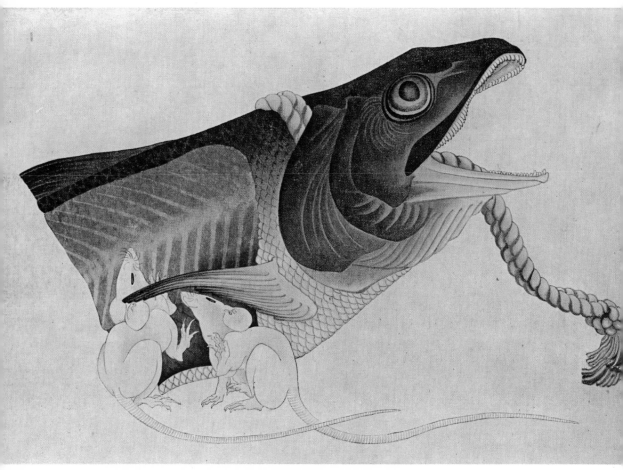

19. *Hokusai* ◆ *Salmon and White Mice* ◆ from an album of paintings, color on paper ◆ Yoshinobu Daishō collection ◆ The two white mice that accompany the fish are the kind of freakish touch beloved by the ukiyo-e artist. More surprising is Hokusai's originality in using such an unpromising subject—half of a freshly caught salmon —as a theme for this type of picture.

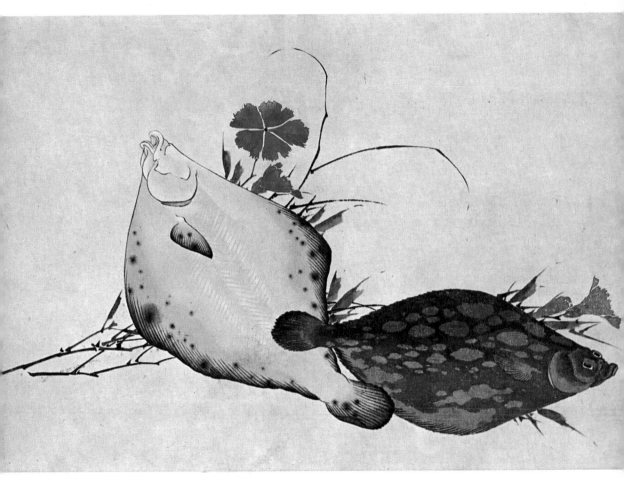

20. *Hokusai* ◆ *Flounders and Carnations* ◆ from an album of paint-
ings, color on paper ◆ Yoshinobu Daishō collection ◆ An advertise-
ment in a book written by Hokusai in late life says, in effect, "orders
accepted for albums of paintings." For many years the present
author was perplexed as to what this referred to; finally he came
across an example in Osaka. The work shown here is from another,
similar album, which shows produce, flowers, etc., throughout the
four seasons of the year. Plates 19, 21, and 22 are also from the same
album. They are all marked by their clear, sophisticated line and
subtle use of color. Note here the skillful suggestion of the texture of
the fish scales.

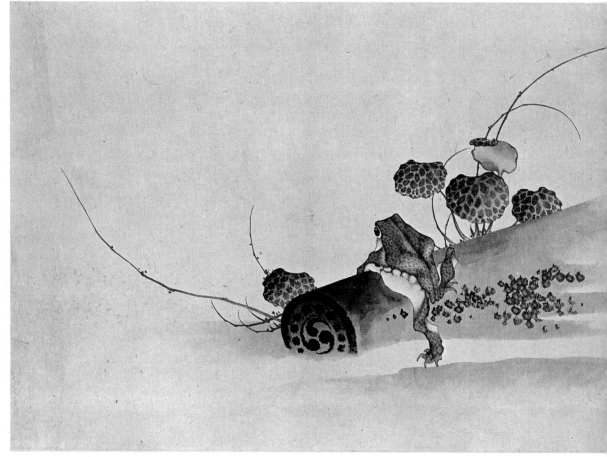

21. *Hokusai* ◆ *Frog on an Old Tile* ◆ from an album of paintings, color on paper ◆ Yoshinobu Daishō collection ◆ In a damp, shady corner of the garden at the back of the house lies a rooftile, doubtless dislodged by a typhoon and now discarded. The creeping saxifrage curls across the picture, and a frog clambers timorously onto the half-buried tile. It is a scene of unusual poetic feeling for Hokusai. Yet the subtle skill with which he suggests the movement of the frog's body as it scrambles onto the tile is completely typical, and one detects a touch of the artist's usual restless power in the tendrils of the saxifrage.

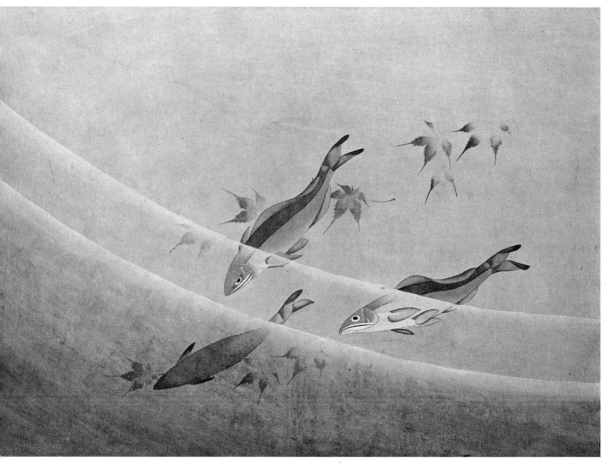

22. *Hokusai* ◆ *Sweetfish* ◆ from an album of paintings, color on
paper ◆ Yoshinobu Daishō collection ◆ The signature on the last
picture of this album shows that the work is a product of the
tranquil period near the close of the artist's life. It is interesting to
compare this work with a similar picture of sweetfish done by
Hiroshige (Pl. 57).

23. *Hokusai* ◆ *Persimmons* ◆ part of a horizontal scroll, color on paper ◆ Tetsuji Yura collection ◆ This picture is part of a scroll devoted to agricultural products of the twelve months of the year. The persimmons are done with simple, rapid strokes reminiscent of a painting manual, which here creates a clean, fresh texture that adds much to the value of the work. Both the vigorous strokes, done with the brush held upright, and the method of applying color on the ripe persimmons create a vivid impression of being the result of direct observation.

Works of Hiroshige

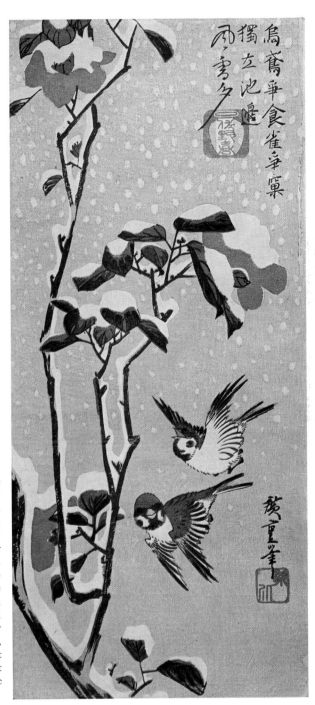

24. *Hiroshige* ◆ *Snow-Covered Camellias and Sparrows* ◆ *ōtanzaku* ◆ published by Sanoki ◆ Hamakichi Murakami collection ◆ Great flakes of snow are falling steadily from leaden skies. The snow that settles on the winter camellia further heightens the beauty of its red petals. This alone would be enough to make any man of sensibility, gazing at the scene from the snug security of his room on a winter's day, wax poetic; and with the addition of the sparrows, busily chirping as they fly through the snow, the picture acquires an atmosphere that even the least poetic of minds might appreciate. The work is surely one of the finest of Hiroshige's *kachō-ga*.

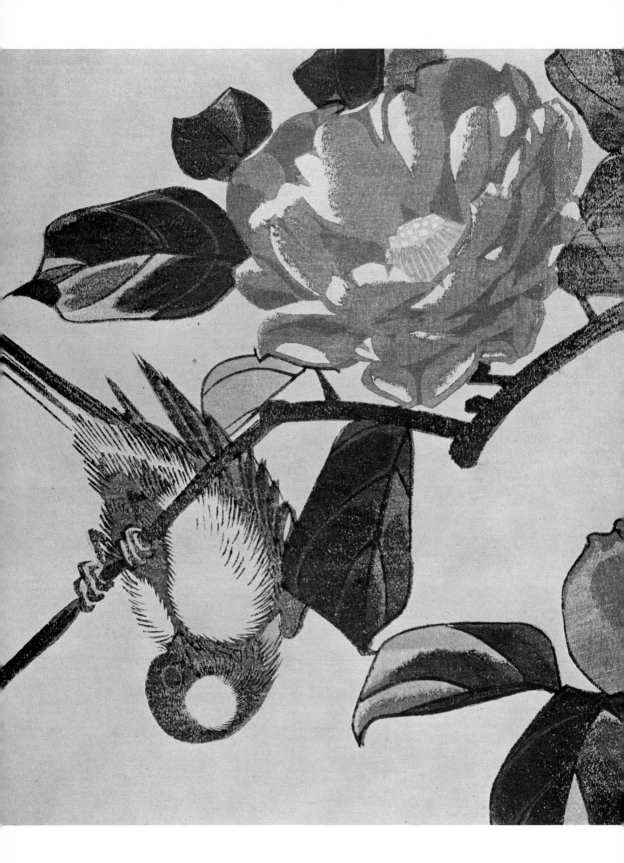

25-26. *Hiroshige* ◆ *Camellias and Bird* ◆ *ōtanzaku* ◆ Yasusaburō Hara collection ◆ The composition of this picture irresistibly recalls the *haiku* in its brevity and poise. The starting point is the large flower open at the upper right. Just below it to the left, the bird creates a momentary movement, setting up a rhythm and creating a pivotal point. Then the twig drops away in a slender line to the bottom left, where another flower blooms at its tip.

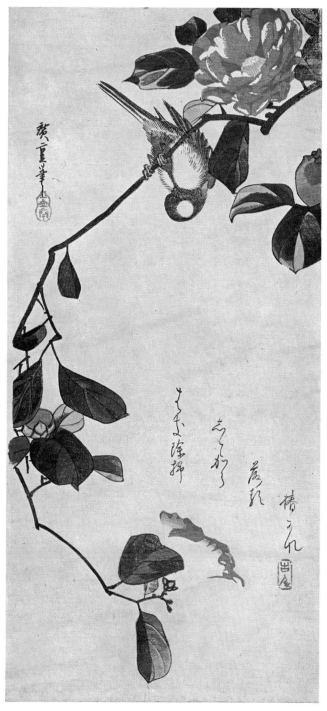

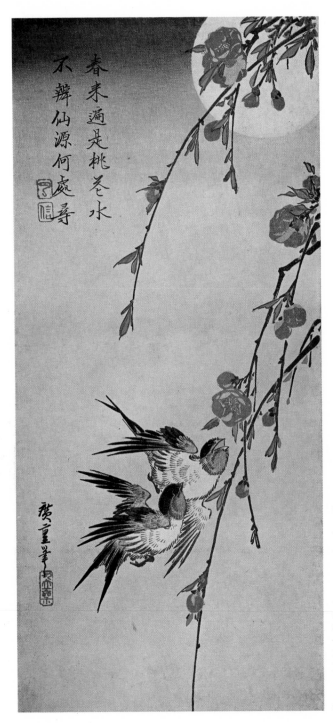

春来遍是桃花水
不辯仙源何處尋

27. *Hiroshige* ◆ *Peach Blossoms and Baby
Swallows* ◆ *ōtanzaku* ◆ Susumu Uchi-
yama collection ◆ In March, the cold
recedes and the first signs of spring
appear. The peach blossoms bloom in
the garden, telling of the joy of life
renewed. About this time, the swallows
come flying over the ocean from the
south to Japan, where they build their
nests under the eaves and rear their
young. In this picture, two baby swal-
lows are squabbling over an insect they
have found on a peach branch, while the
moon, shedding its pale light over the
scene, adds to the magic of a mild spring
night.

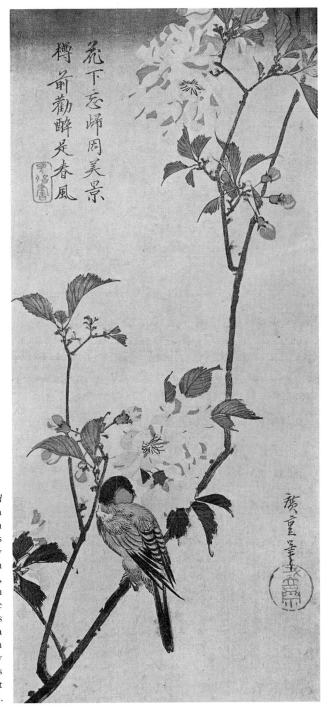

28. *Hiroshige* ◆ *Cherry Blossoms and Swallow* ◆ *ōtanzaku* ◆ Yasusaburō Hara collection ◆ When a swallow appears in a picture with cherry blossoms, it is usual for the swallow to be shown busily carrying food back to its young, which are soon to leave the nest. In this picture, however, the inscription by Ryōshin tells of the poet standing beneath the cherry blossoms, so smitten by its beauty that he forgets to go home—a comment both on life in general and on the apparent negligence of the swallow in the print. This work demonstrates very clearly the poetic atmosphere that distinguishes Hiroshige from Hokusai.

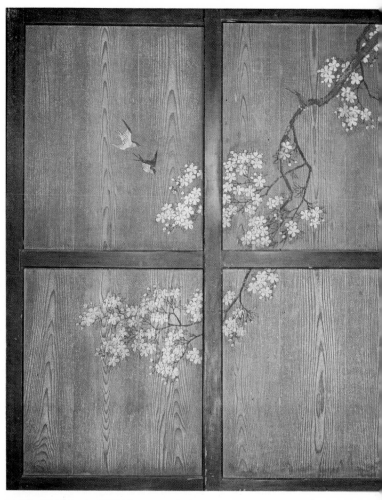

29-30. *Hiroshige* ◆ *Wild Cherry* ◆ paintings on cryptomeria wood doors ◆ inner sanctuary of the Main Hall, Senkoku-ji temple, Kanagawa Prefecture ◆ The existence of these paintings by Hiroshige, now designated an important cultural property by Kanagawa Prefecture, did not become public knowledge until around 1930. The paint is peeling rather badly, but it is still apparent that these are among Hiroshige's greatest works. Ryōshin, the poet-priest who is believed to have been the elder brother of Hiroshige's first wife, was chief priest at the temple from 1834 to 1840. Evidence suggests that these works were painted around the year 1838, when Hiroshige was forty-two years of age. The choice of wild cherry—which is paler and more fragile than the cherry seen in and around the towns—as a subject gives the picture a remote, insubstantial air.

66

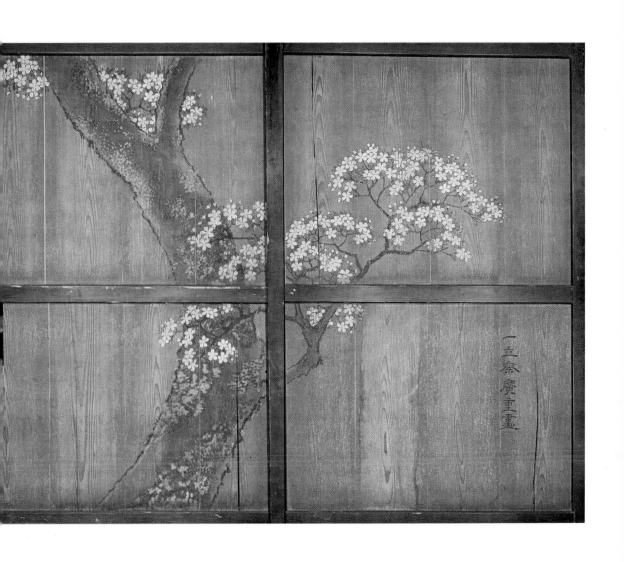

67

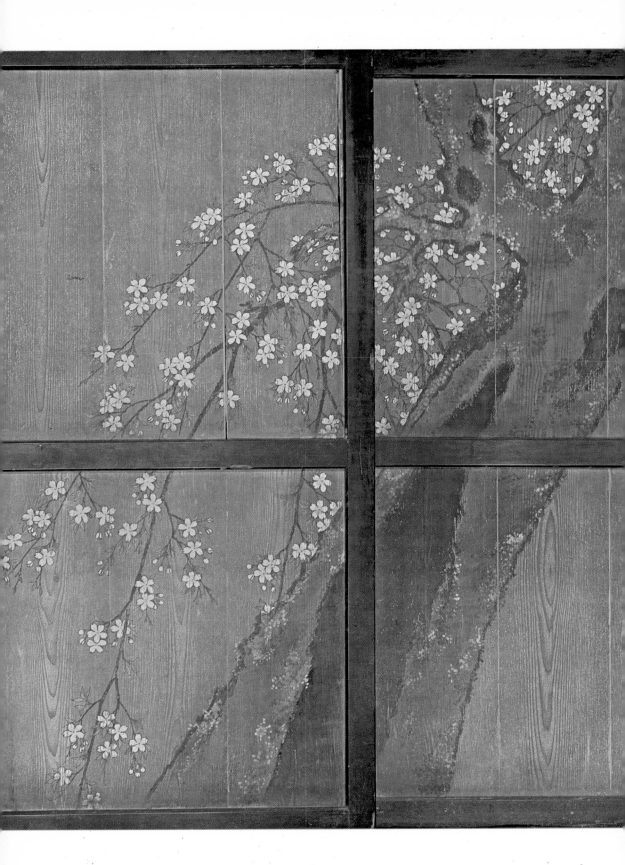

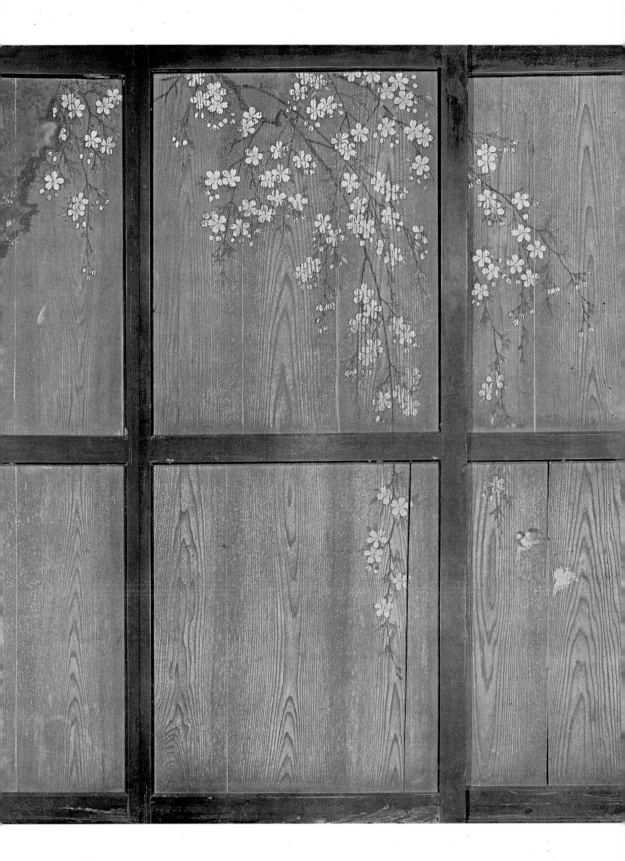

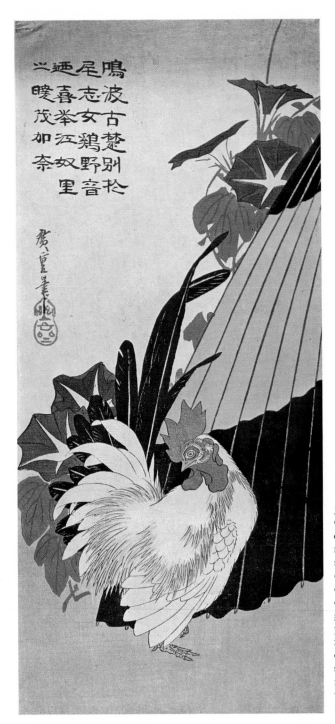

31. *Hiroshige* ◆ *Umbrella and Morning Glories* ◆ *ōtanzaku* ◆ Yasusaburō Hara collection ◆ The rain that fell during the night lifted around dawn, and now the sun is gleaming bright in a clear sky. An oiled paper umbrella with a bull's eye design has been put out in the sun to dry beside the newly opened morning glories. A cockerel comes walking past. Hiroshige did twenty-five works in the *ōtanzaku* form; many of them date from the year 1832, when Hiroshige suddenly revealed himself as a master of the poetic *kachō-ga*, a genre in which Hokusai could not hope to rival him.

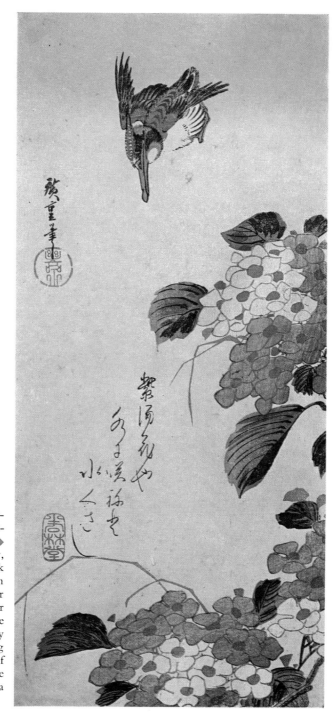

32. *Hiroshige* ◆ *Hydrangeas and King-fisher* ◆ *ōtanzaku* ◆ published by Jaku-rindō ◆ Kōshirō Mitsuno collection ◆ The kingfisher with its tiny body, brilliantly colored wings, and long beak is still to be seen occasionally, darting in and out amongst the flags and water weeds bordering some quiet stream or irrigation channel. Here, Hiroshige shows the bird, doubtless attracted by the scent of the flowers below, darting down out of the bright, empty sky of early summer. Another printing of the picture, put out by Kikakudō, has a somewhat different color scheme.

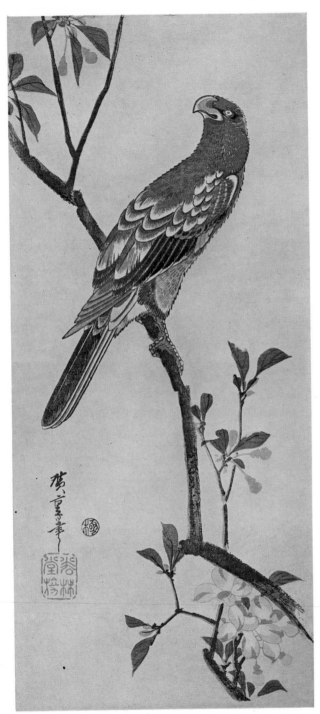

33. *Hiroshige* ◆ *Aronia and Parrot* ◆ *ōtanzaku* ◆ published by Jakurindō ◆ Yasusaburō Hara collection. One of the most important elements in the *kachō-ga* is the coloring. For example, the style of Sō Shiseki and members of the Nampin school (an Edo period school of painting that derived from the nature studies of Ming and Ching China) depends almost entirely on color for its effect. Thus in later years, when Hiroshige's work fell far below the standards of a print design such as this, his pictures came to evoke a quite different type of effect.

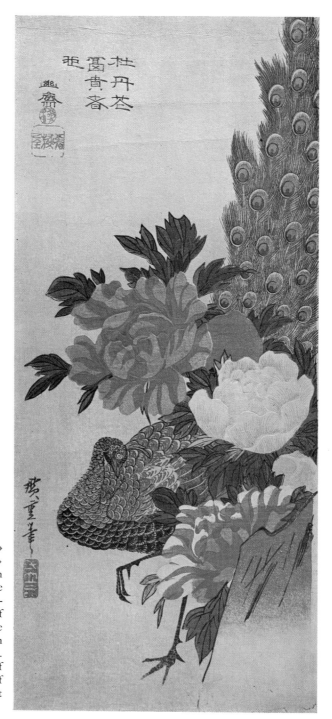

34. *Hiroshige* ◆ *Peonies and Peacock* ◆
ōtanzaku ◆ published by Wakasaya ◆
Hamakichi Murakami collection ◆ An
inscription at the upper left says "The
peony is a wealthy noble among flow-
ers." All Hiroshige's nature studies of
this period are noted for the brilliance
of their coloring, and the combination
of colors in this print is especially fine.
In this attempt to convey the texture of
the blooms, Hiroshige makes use of
techniques such as printing without
color and without outline.

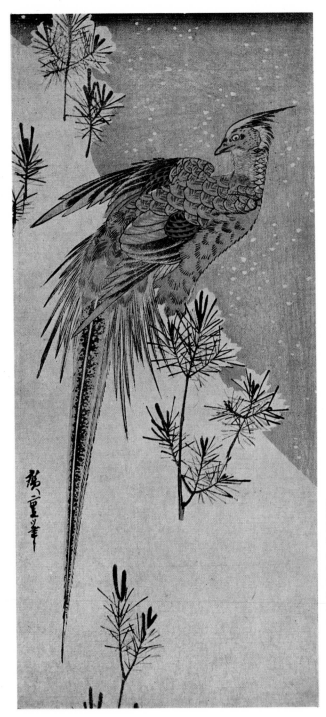

35. *Hiroshige* ◆ *Copper Pheasant on a Snowy Hillside* ◆ *ōtanzaku* ◆ published by Jakurindō ◆ Kōshirō Mitsuno collection ◆ For the majority of the men responsible for the literature and art of old Edo, art was an escape from society, a seeking after a type of beauty remote from the preoccupations of everyday life. In Hiroshige, likewise, there is a strong hankering after remoteness and tranquillity, a trend that finds frequent expression in his flower-and-bird pictures. Here, for example, the background of a lonely, snowy hillside with tiny pine trees gives the bird, for all the brilliance of its plumage, an air almost of mystery.

74

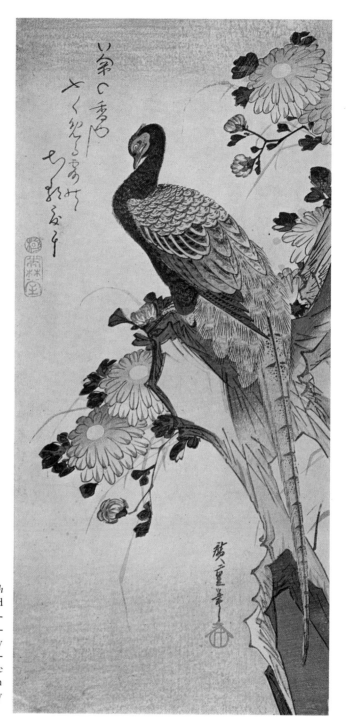

36. *Hiroshige* ◆ *Pheasant on a Bank with Chrysanthemums* ◆ *ōtanzaku* ◆ published by Jakurindō ◆ Kōshirō Mitsuno collection ◆ This beautiful, if rather improbable, scene belongs in the same category as the preceding print. The *haiku* inscribed at the top left strikes the same note: "A scent of chrysanthemums, each time the blooms scatter the dew they hold."

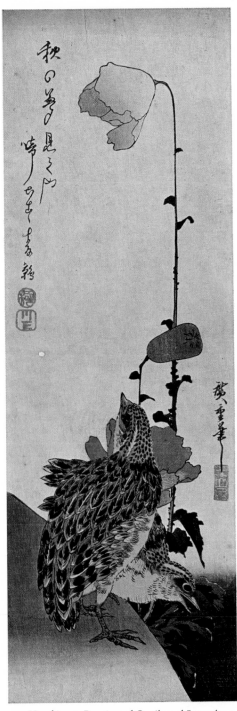

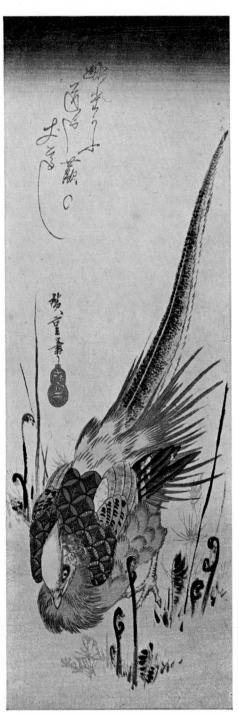

37. *Hiroshige* ◆ *Poppies and Quails* ◆ *chūtanzaku* ◆ published by Kawashō ◆ Hideo Hagiwara collection ◆ Painters in the *Yamato-e* tradition were fond of showing quails and ripe millet in the same picture, but in this work Hiroshige substitutes a poppy in bloom.

38-39. *Hiroshige* ◆ *Ferns and Pheasant* ◆ *chūtanzaku* ◆ Yasusaburo Hara collection ◆ The poem inscribed above the picture tells simply of the poet losing his way because ferns have grown over the path; what connection there is between ferns and pheasants is not clear.

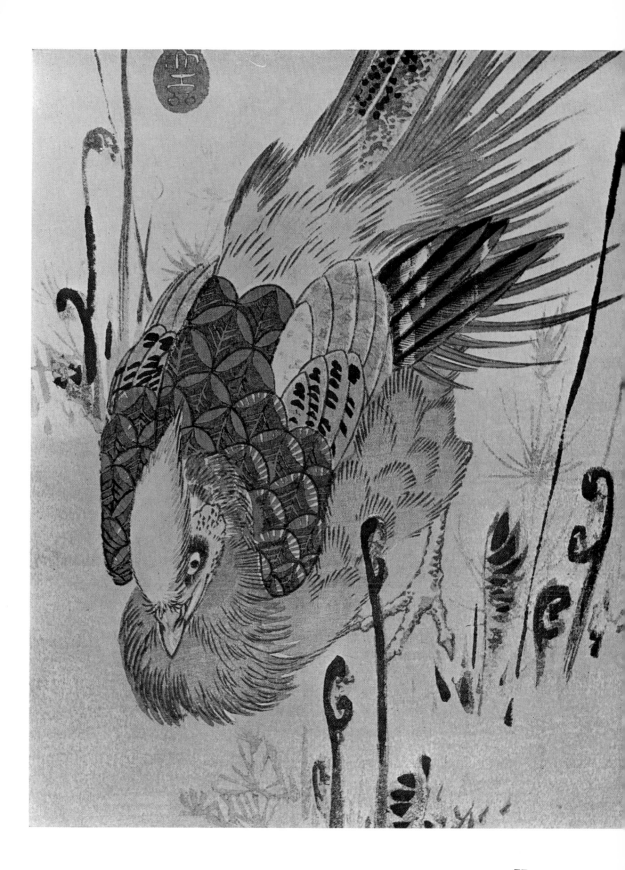

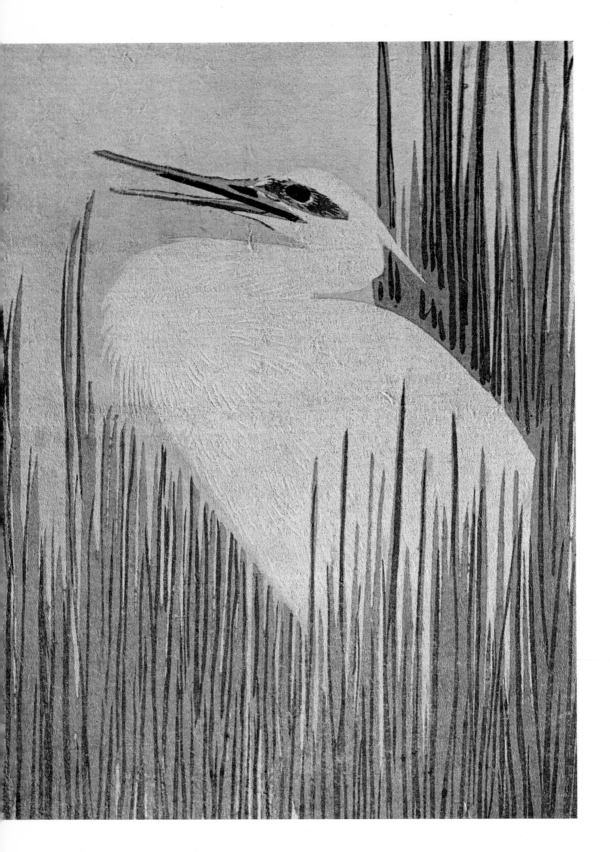

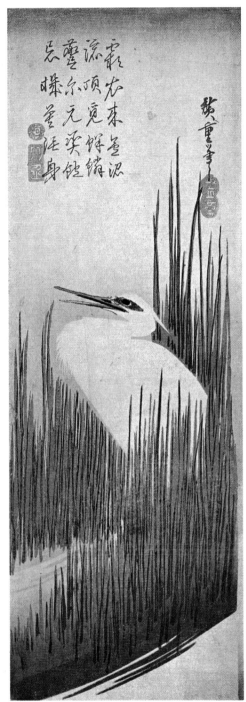

40-41. *Hiroshige* ◆ *Bulrushes and Snowy Heron*
◆ *chūtanzaku* ◆ published by Kawashō ◆
Tokyo National Museum ◆ Only Hiroshige,
surely, could have created the marvellous
poetry of this scene of a snowy heron that has
alighted among the tall, straight bulrushes by
a river and is calling forlornly to its mate. Few
of his other *chūtanzaku* works can rival this
one; indeed, it dates from the period of his life,
around the age of forty, when he seems to have
been probing most deeply into the remoter,
more mysterious aspects of the beauty of
nature.

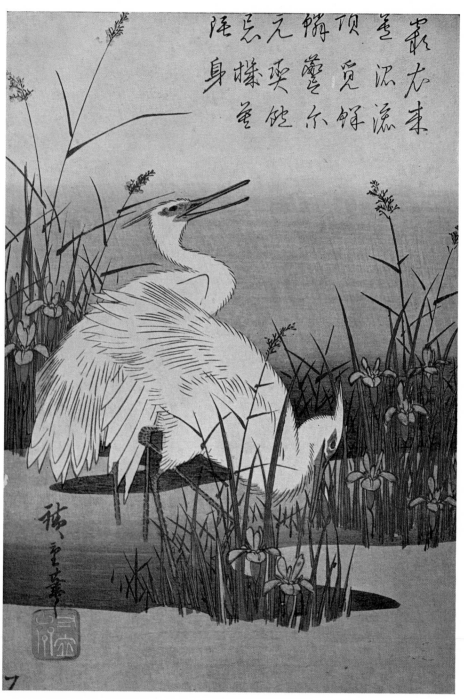

42. *Hiroshige* ◆ *Sweet Flags and Snowy Herons* ◆ *chūban tate-e* ◆
Tokyo National Museum ◆ Two snowy herons create a highly
atmospheric scene as they wade through the water of a stream and
make their way through the sweet flags flowering on its bank.
Snowy herons are still to be seen in country districts of Japan, their
white forms graceful among the green rice plants in the paddy
fields, or roosting at dusk in trees by the shore, like strange white
flowers among the branches.

43. *Hiroshige* ◆ *Sweet Flags and Snowy Heron* ◆ *ōtanzaku* ◆ Hideo Hagiwara collection ◆ Other versions of this print survive in which the coloring is somewhat different. The flags are the same on the whole, but in some prints the feathers on the heron's legs are yellow; in others, the back is done in light indigo, shading into light gray at the top, or half in light brownish gray and half in light indigo. The beauty of the white heron as it alights amidst the flags shows the woodblock print *kachō-ga* at its very best.

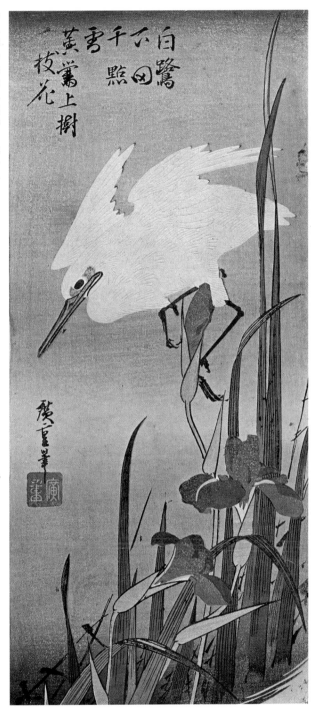

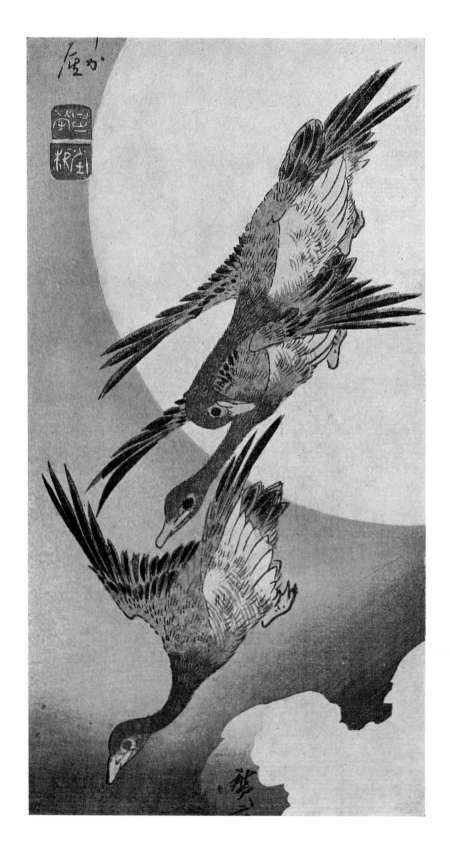

44-45. *Hiroshige* ◆ *Wild Geese Alighting by Moonlight* ◆ *chūtanzaku* ◆ published by Shōeidō ◆ Sentarō Kondō collection ◆ Three wild geese sweep across the moon and down through the clear autumn sky with its billowing clouds below. The composition manages with remarkable skill to suggest space and freedom within the very restricted framework of the *chūtanzaku*. It is a particularly satisfying work, with a uniquely haunting elegance. Fifty-seven *chūtanzaku* works by Hiroshige are known to have been put out by Kawashō and Fujihiko in the years from 1832 on.

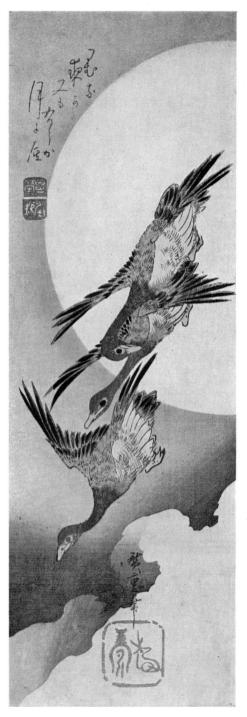

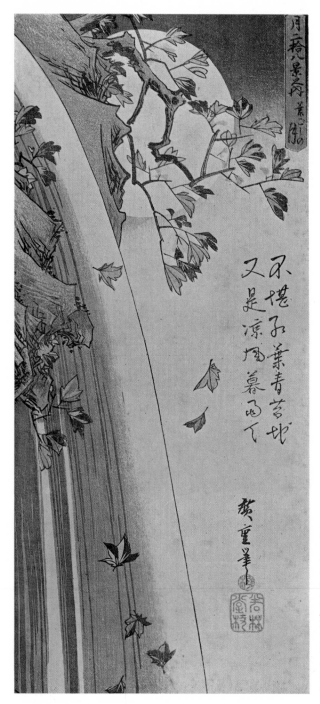

46. *Hiroshige* ◆ *The Moon Beyond the Leaves*, from "Twenty-eight Views of the Moon" ◆ *ōtanzaku* ◆ published by Jakurindō ◆ Yasusaburō Hara collection ◆ Copies of this print are very rare. It is not known how many of this series were actually published, but only two prints survive today. Some of the copies were published by Kikakudō, others by Jakurindō, but the latter are believed to represent the original printing. The poetry of the scene in this print, with its red maple leaves scattering over the moonlit fall, sets Hiroshige apart from Hokusai more clearly than anything else.

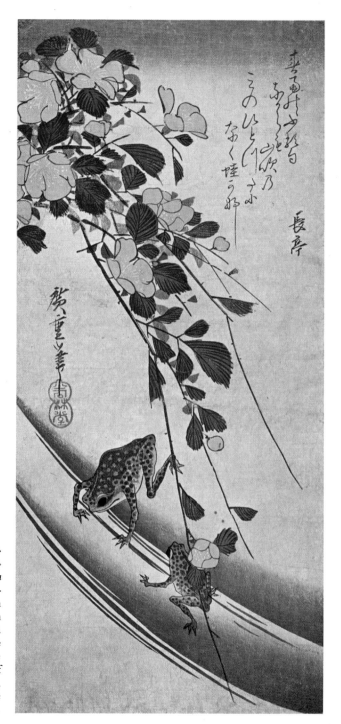

47. *Hiroshige* ◆ *Yamabuki and Frogs* ◆ *ōtanzaku* ◆ published by Jakurindō ◆ Tokyo National Museum ◆ The *kyōka* (thirty-one-syllable satirical poem), inscribed at upper right, alludes, with untranslatable puns, to the frogs, which despite the spring rain have not even a raincoat of *yamabuki* flowers. Yet the concision and poetry of the work place it in the world, not of the *kyōka*, nor of *senryū* (seventeen-syllable satirical poem), but of the *haiku*. In a sense, Hiroshige was the Bashō of the ukiyo-e world.

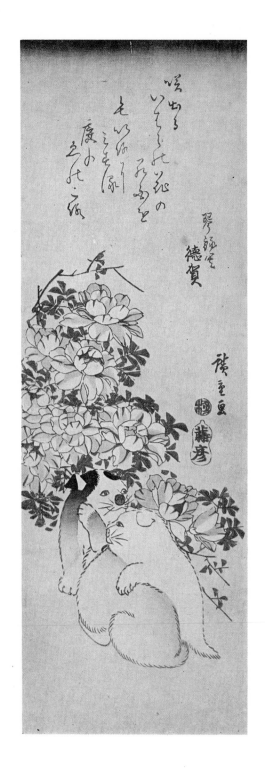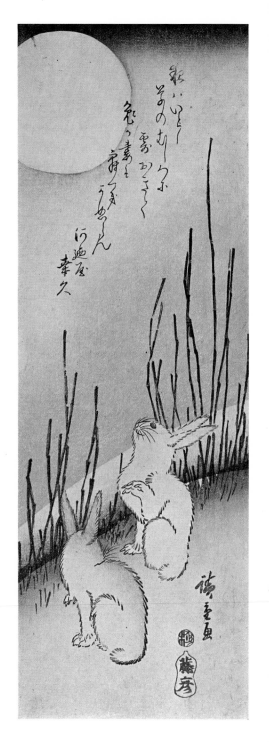

86

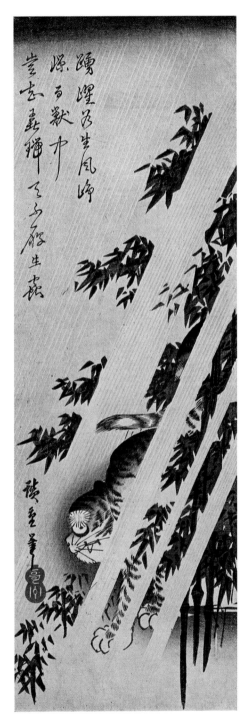

48-50. *Hiroshige* ◆ *Roses and Puppies; The Moon and Hares; Tiger in a Bamboo Grove* ◆ three *chūtan-zaku* ◆ published by Fujihiko ◆ Tokyo National Museum (Pls. 48, 49); Yasusaburo Hara collection (Pl. 50) ◆ This series, of which eight prints are known to exist, shows the twelve animals of the Chinese zodiac, and dates from Hiroshige's late middle years. The pictures all have a charming, fable-like quality. Note especially the suggestion of the pale light of the moon in Pl. 49, and the effective use of one spot of red for the hare's eye.

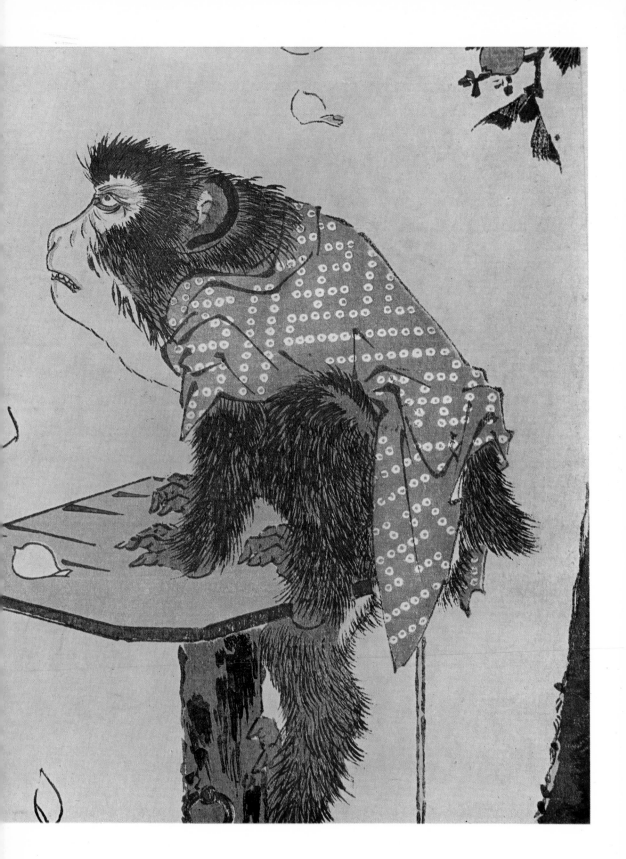

51-52. *Hiroshige* ◆ *Pet Monkey* ◆ *ōtanzaku* ◆ published by Jakurindō ◆ Yasusaburō Hara collection ◆ This has always been one of the more famous of Hiroshige's works, possibly because of the novelty and "strength" of the subject. In Chinese and Japanese verse, monkeys occasionally put in an appearance, but there their cries, heard deep in the mountains, evoke associations of autumn and loneliness. One wonders why the poetic Hiroshige should have passed over the opportunities this suggested and chose to depict instead a pet monkey tied up beneath falling cherry blossoms.

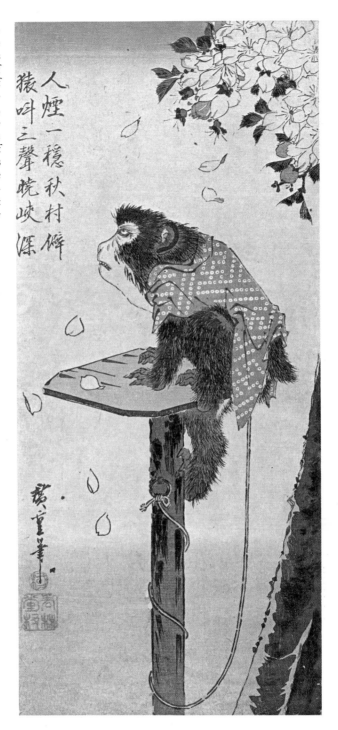

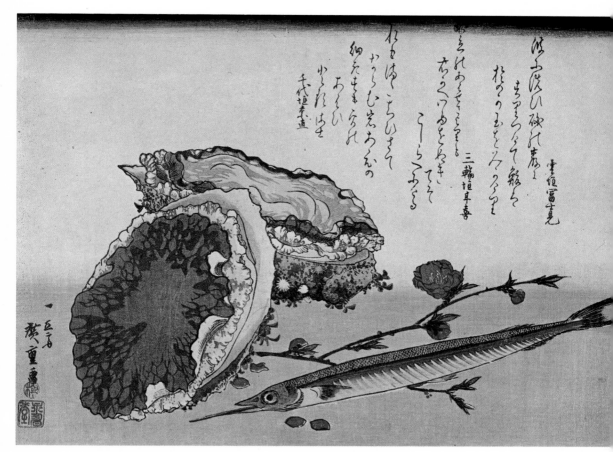

53. *Hiroshige* ◆ *Abalone and Halfbeak* ◆ *ōban yoko-e* ◆ published by Eijudō ◆ Yasusaburō Hara collection ◆ The abalone is decidedly homely in appearance, but the halfbeak is sleek and elegant, and the red peach blossom is a pretty touch. Hiroshige was, after all, a townsman, a typical son of old Edo. In this, he was very different from Hokusai, who retained to the end something of his comparatively rustic origins.

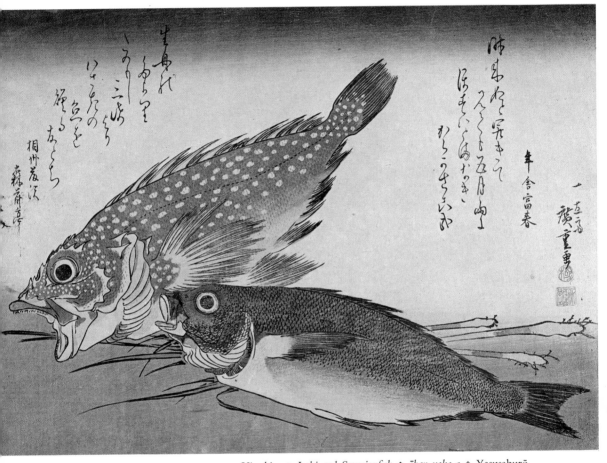

54. *Hiroshige* ◆ *Isaki and Scorpionfish* ◆ *ōban yoko-e* ◆ Yasusaburō
Hara collection ◆ Chief among Hiroshige's series of pictures of fish
are two *ōban yoko-e* series, two *chūban yoko-e* series, and two *chūban
tate-e* series, although he also did other fish pictures on fan paper.
The finest of them all are ten prints with *kyōka* that were published
by Eijudō around 1832, and another ten, also with *kyōka*, published
by Yamashō. These were sold in albums along with other verse by
the amateur poets association that commissioned the works. The
inclusion of stems of ginger with the two fish shown here suggests
that they are soon to find their way to the table. As in all the works
in this series, the texture and "fishiness" of the subject is admirably
conveyed. Even so, the works are straightforward depictions from
nature; there is little of the artist's own personality as there is in
similar works by Hokusai.

91

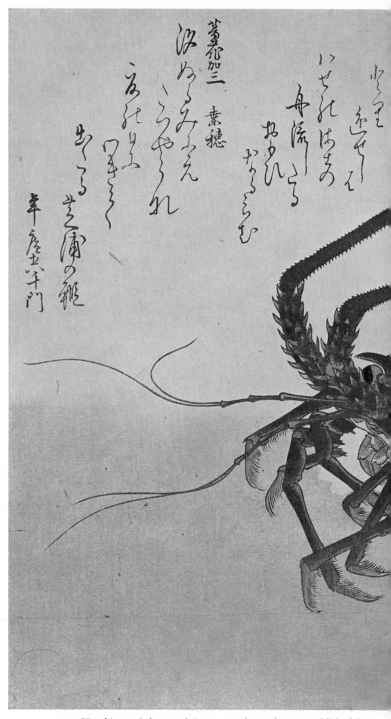

汐のうみみつえ
いせれはその
ひとつる 葉穂
加三

波のうみみつえ
いらやつれ

出づる芝浦の龍
辛倉立斗門

55. *Hiroshige* ◆ *Lobster and Prawns* ◆ *ōban yoko-e* ◆ published by
Eijudō ◆ Kōshirō Mitsuno collection ◆ The *kyōka* was mostly an
art, not of the professional writer, but of the ordinary merchants of
Edo, who formed societies and published collections of their own
verse on occasions such as the New Year. From the Kansei era
(1789–1801) on, it was common for them to commission pictures

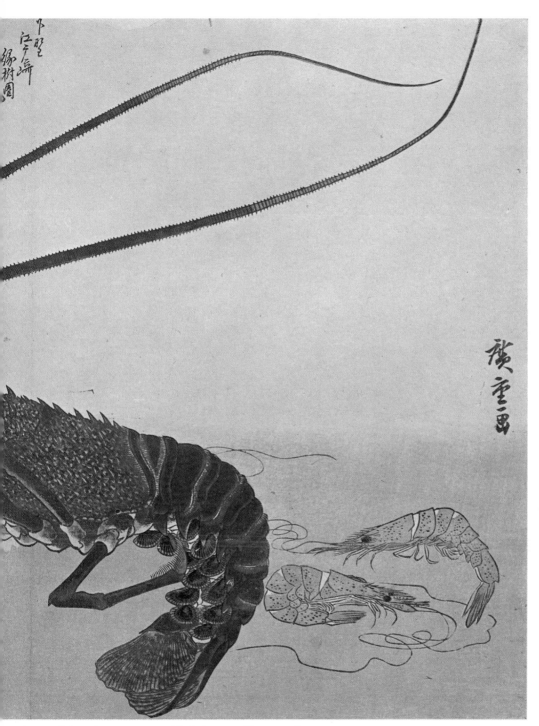

from well-known artists to go with their verse. Utamaro, for example, produced much fine work in this way. This collection of fish was done by Hiroshige in response to such a commission. It was published around 1832, at roughly the same time as the flower-and-bird *ōtanzaku*, and helped to firmly establish Hiroshige's position in the world of art. The faithfulness to life in this print is remarkable.

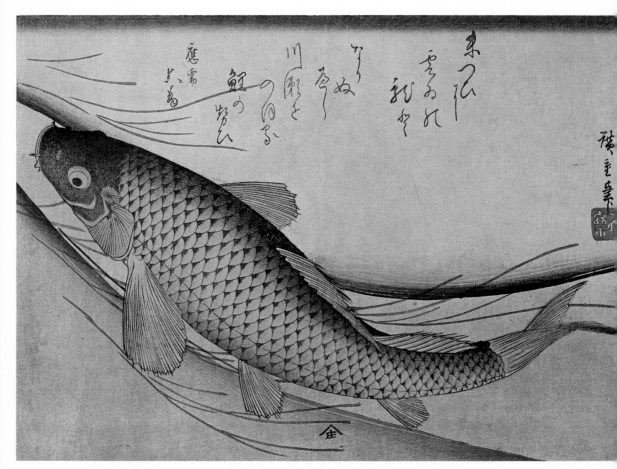

56. *Hiroshige* ◆ *Carp* ◆ *ōban yoko-e* ◆ published by Yamashō ◆
Yasusaburō Hara collection ◆ Copies of this print are commoner
than that reproduced in Plate 57, but most of them are from a later,
inferior printing without the waterweed seen in the version repro-
duced here. To compare them with the Hokusai carp shown in
Plate 16 is to realize the difference in temperament between the two
men. Hokusai himself dwells within his picture; Hiroshige is content
to observe from without.

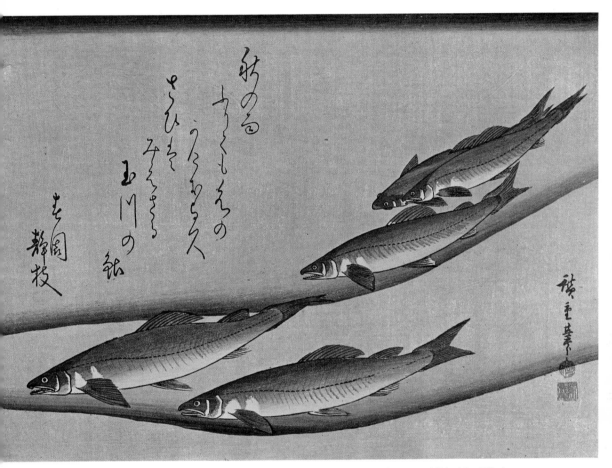

秋
の
う
を
うくくも
く
の
うを
みえを
みくきき
玉
川
の
鮎

吉
園
静
枚

57. *Hiroshige* ◆ *Sweetfish* ◆ *ōban yoko-e* ◆ published by Eijudō ◆
Yasusaburō Hara collection ◆ The right to publish this work later
passed from Eijudō to Yamajin. It is interesting to compare this
print with a painting by Hokusai of a similar subject (Pl. 22). Though
without the energetic imagination of the Hokusai, this print skillfully
conveys the sleek grace of the sweetfish as they glide through the
moving water. The sweetfish is highly prized as food, and one
almost seems to see the fisherman waiting on the bank above.

95

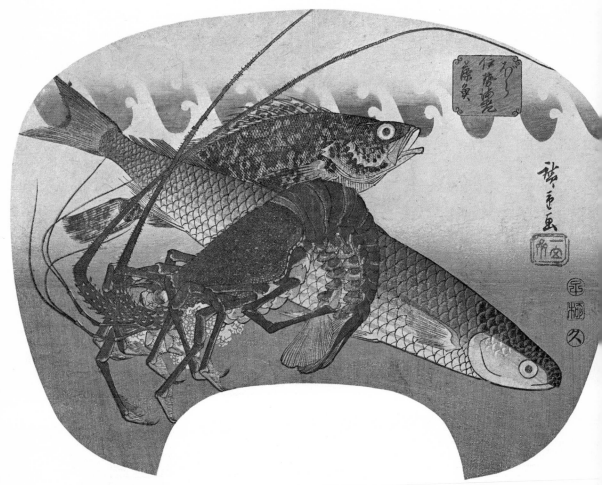

58. *Hiroshige* ◆ *Lobster, Gray Mullet and Mouo* ◆ fan print ◆ published by Maruhisa ◆ Hamakichi Murakami collection ◆ This print is a late work and probably dates from 1852. There is a spiritual calm lacking in the works of the 1830's, but also a certain loss of life. It is interesting as a specimen of a type of work by Hiroshige of which few specimens survive, though there is also a fan print from his middle years showing lobster, black porgy, and gurnard.